*The Campus History Series*

# YORK COLLEGE
# OF PENNSYLVANIA

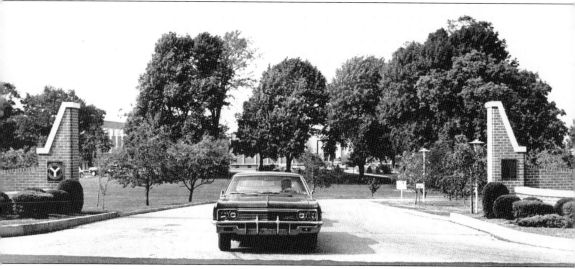

A car exits the main entrance gates of York College of Pennsylvania in 1968. The York College of Pennsylvania logo is on the left portal. The dedication plaque on the right portal lists the trustees who contributed greatly to the development of the private, independent college during the terms of presidents J. F. Marvin Buechel (1956–1958) and Ray A. Miller (1959–1975): John A. Albohm, W. Burg Anstine, Esq., Elliott L. Breese, Melvin H. Campbell, Mrs. Jesse Chock, John P. Connelly, Frederick G. Dempwolf, Walter S. Ehrenfeld, Herman A. Gailey, M.D., Russel G. Gohn, Bruce A. Grove, M.D., Harvey A. Gross, Esq., Harlowe Hardinge, John W. Hennessey, Ben Lavetan, Raymond S. Noonan, Gerard V. Patrick, John T. Robertson, Benjamin M. Root, Mrs. George E. Schenck, John C. Schmidt, Marvin G. Sedam, Charles S. Seligman, Beauchamp E. Smith, Horace E. Smith, Esq., J. Kenneth Stallman, John L. Toomey, John A. Waltersdorf, Joseph R. Wilson, and Charles S. Wolf. The portal was presented by Raymond S. Noonan.

*On the cover*: This building, on the southeast corner of Duke Street and College Avenue in York City, at one time was home to all three of the ancestral institutions of York College of Pennsylvania—York County Academy, York Collegiate Institute, and York Junior College. It was the second building to house York Collegiate Institute and is pictured on the cover as it looked in 1886, the year it was dedicated as a memorial to York Collegiate Institute founder Samuel Small. The original York Collegiate Institute building constructed on that site in 1873 was destroyed by fire in 1885. The photograph was taken by Shadle and Busser, well-known photographers of that era and into the 20th century. (York College of Pennsylvania Archives.)

*The Campus History Series*

# YORK COLLEGE OF PENNSYLVANIA

CAROL MCCLEARY INNERST

ARCADIA
PUBLISHING

Published by Arcadia Publishing
Charleston SC, Chicago IL, Portsmouth NH, San Francisco CA

Printed in the United States of America

Library of Congress Catalog Card Number: 2007929511

For all general information contact Arcadia Publishing at:
Telephone 843-853-2070
Fax 843-853-0044
E-mail sales@arcadiapublishing.com
For customer service and orders:
Toll-Free 1-888-313-2665

Visit us on the Internet at www.arcadiapublishing.com

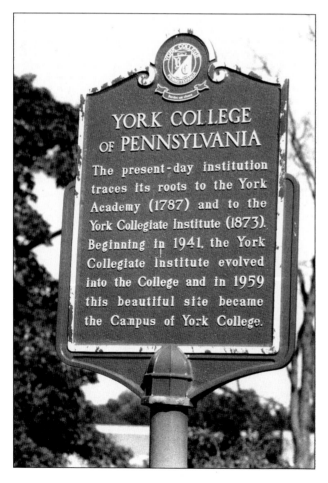

A marker near the main
entrance to the campus
on Country Club Road
acknowledges the ancestral
institutions and historical
roots of present-day York
College of Pennsylvania.

# CONTENTS

# ACKNOWLEDGMENTS

The efforts of many individuals helped to make this photographic history of York College of Pennsylvania possible. But special thanks must go to Amanda Hickey-Bauer, archivist at Schmidt Library, who several times a week for many months spent hours with me in the archives, pulling out countless boxes of old photographs and records to be examined. Equally important, she assisted with the research required to find information not readily at hand, and provided the necessary technical support for the project. York College of Pennsylvania art director Lance Snyder and photographers Bob Lenz and Mike Adams deserve kudos for offering their expertise as needed. The invaluable donations of photographs and memorabilia to the archives over many years by alumni and nearly a dozen local photographers cannot be overlooked. Their generosity in contributing books, papers, artifacts, and photographs to the college archives has created a valuable resource now available for the edification and enjoyment of everyone in the community. Archival photographs often offer scant information, and written materials may contain errors. If any errors have found their way into this book, I apologize. These acknowledgments would not be complete without an expression of gratitude to York College of Pennsylvania president George Waldner for commissioning this book for past and future generations of students and all who are interested in history and education.

# INTRODUCTION

The roots of York College of Pennsylvania reach deep into the history of the York community. The college can trace its lineage directly to three ancestral institutions. The first is the York County Academy, an English classical school founded by clergy of the Episcopal Church of St. John the Baptist and incorporated September 20, 1787. Its forerunner was a school taught in York before the Revolutionary War by the Rev. John Andrews, a missionary who came to York as rector of St. John's parish in 1767. Andrews raised the funds to construct a church before leaving York in 1772 for the University of Pennsylvania. The church became an arsenal during the Revolutionary War, and the pulpit remained empty until 1784 when Rev. John Campbell took charge of the parish, repaired the church, and raised funds to build an academy. Classes met in a redbrick building erected directly across from the church on North Beaver Street.

Despite early ambivalence of the predominantly German-speaking population in York, the York County Academy fared nicely under trustees that included James Smith, a signer of the Declaration of Independence, and Col. Thomas Hartley, a Revolutionary War hero. As early as 1798, the school accepted girls. York County Academy students became leaders in the community. From 1800 to 1837, the York County Academy building was the headquarters for volunteer troops of eight uniformed militias formed in response to the government's order to be prepared to meet the "tyrant foe" in the country's cause. In 1858, York County Academy started a program to train teachers for the elementary grades. It operated the York County Normal School until 1921. About this time, the new Pennsylvania compulsory school attendance law and growing competition from public schools began to severely reduce the pool of potential private college preparatory students. To survive, the academy abandoned its aging building on June 10, 1929, and joined forces with the York Collegiate Institute in its newer building at Duke Street and College Avenue.

The York Collegiate Institute, which opened its doors to students September 15, 1873, is the second lineal ancestor of contemporary York College of Pennsylvania. York Collegiate Institute was founded and financed by prominent York businessman Samuel Small. Its program, influenced by Presbyterian clergy, offered classical, college preparatory courses stressing literature, history, and philosophy, but added commercial and professional studies to the curriculum. Like York County Academy, it stressed religious instruction. York Collegiate Institute soon was educating more than 100 boys and girls in the classical, scientific, or commercial courses or the young ladies' department. The night of December 7, 1885, a fire destroyed the building. The Small family rallied, and three nephews of the founder rebuilt York Collegiate Institute on the same site. The new building, architecturally notable for its six-story central tower and Gothic feel, was dedicated March 15, 1887.

United under one roof in downtown York beginning in 1929, York County Academy and York Collegiate Institute survived the Great Depression. Students completing the course of study received a joint diploma from the two schools. But by 1940, the secondary departments were operating at a financial loss. Prof. Lester F. Johnson, who in 1934 assumed the dual titles of both president and principal of the two institutions, recommended to the trustees that the facilities be converted to a junior college to better serve the educational needs of the community. After a survey showed that 42 students would enroll to be able to take the freshman year of a liberal arts program in York, the two oldest private schools in the city officially became the Junior College of York Collegiate Institute. The facilities were refurbished and classes began October 3, 1941. The school soon became known as York Junior College. Enrollment grew rapidly after World War II as the GI Bill opened the doors of higher education to returning veterans. With the burgeoning population of the junior college taxing the limited space of the old building, the secondary school program was discontinued in 1947 and York Collegiate Institute and York County Academy went out of business.

By 1957, Korean War veterans had helped boost enrollment at York Junior College to 500, and the old building it occupied was bursting at the seams. That same year, the board and York Junior College president J. F. Marvin Buechel purchased the Out Door Country Club's 57.5-acre property along Country Club Road for $250,000. With community support, a new campus began to take shape on what had been a nine-hole golf course. The first new building, York Hall, was completed in 1961, with classroom space for 800 students. The new campus was formally dedicated in 1965. Three years later, the junior college era ended with state approval of the request to become a four-year institution granting bachelor's degrees. The transformation of a one-building school on a small city plot to a widely respected institution of higher education with a 155-acre campus was underway.

Today in addition to its 4,600 full-time undergraduate students, York College of Pennsylvania offers master's degree programs in business administration, education, and nursing. But the historical roots and mission of York County Academy and York Collegiate Institute to prepare students for college live on at York Country Day School, a private school near the campus that has been part of the York College of Pennsylvania family since 1975.

The photographs on the pages that follow trace the evolution of an educational enterprise—its leaders and teachers, its students, and its buildings—that over a period approaching three centuries made York College of Pennsylvania the institution it is today.

The following resources made available through the Schmidt Library Archives deserve special mention: *A History of the York County Academy, 1787–1953*, issued jointly by Trustees of the York County Academy and the Historical Society of York County with considerable research and preparation by Mrs. Howard C. Imhoff and Mr. George Hay Kain; *25 Years of Service—York Junior College*, written by Walter Klinefelter and published in 1966 for the 25th anniversary of York Junior College.

# *One*

# THE EARLY YEARS

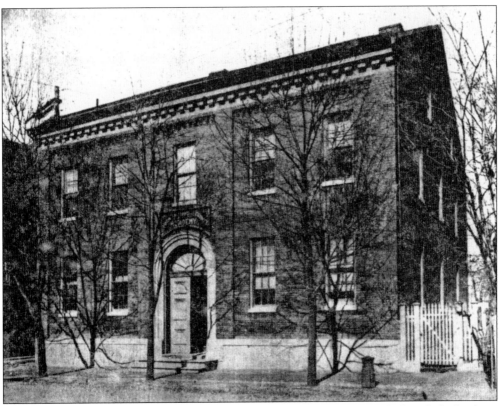

After Rev. John Campbell in 1784 became rector at St. John's Episcopal Church, he built an academy on land purchased in 1785 on North Beaver Street across from the church. The red brick and stone building was "48 feet in front, 57 in depth, and two lofty stories." It was divided into three schools—English, mathematical, and classical. In 1787, the religious school was incorporated as the York Academy with and as part of the church. It later was surrendered to the state and on March 1, 1799, incorporated and endowed as the independent York County Academy (YCA). Historically significant academy educators included Thaddeus Stevens, known for organizing post–Civil War reconstruction in the South and for bringing public schools to Pennsylvania. Edgar Fahs Smith, a University of Pennsylvania provost, attended the academy. The deteriorated building was razed in 1966.

The seed that became YCA was an English classical school taught by Rev. John Andrews (1746–1813), an Episcopal clergyman who came to St. John's Parish in 1767 and supplemented his income by teaching. Through a lottery, Andrews raised funds to erect St. John's Episcopal Church in 1769. He left York in 1772 for the University of Pennsylvania, where he was provost at his death in 1813. This portrait was painted by artist Thomas Sulley.

It was common in the post–Revolutionary War period for churches and other buildings to be financed through lotteries. Rev. John Campbell, rector of St. John's Episcopal Church, in 1792 turned to a lottery to repay William Bailey the money that he had advanced for construction of the York Academy building. To raise $1,782, the lottery sold 2,481 tickets at $2 each. Prizes ranged from $400 to $2.

Col. Thomas Hartley, intimate friend of George Washington, became the first president of the board of York Academy in 1787 and continued as a trustee under the 1799 charter. Hartley, a military hero of the Revolutionary War, commanded the 1st Pennsylvania Brigade at Brandywine, Germantown, and Paoli, and avenged the Wyoming, Pennsylvania, "Massacre of Patriots" by British loyalists and Native Americans. He was a member of the Pennsylvania Convention that ratified the Constitution in 1787 and served in the first six Congresses.

James Smith, signer of the Declaration of Independence, was first president of the board of the independently chartered YCA from 1799 to 1800, when he resigned and became a trustee until his death in 1806. He was a colonel in the First York Battalion in 1775, actively organized troops during the Revolutionary War, became a brigadier general in the Pennsylvania Militia in 1782, and was elected to Congress in 1885. He is buried in the graveyard at First Presbyterian Church of York.

This August 14, 1812, YCA "report card" on Barnitz Eichelberger lists rules that pupils were expected to heed. A noteworthy name on the certificate is Rev. Samuel Bacon, who established York's first Sunday school August 17, 1817, and became a zealous organizer of Sunday schools. Later Bacon accompanied free African Americans who sailed January 31, 1820, from New York for Liberia. Most died of fever, including Bacon on May 12, 1820.

On February 26, 1826, YCA students performed the comedy *Heir at Law* in the attic of the YCA building. Because only males attended the school, female roles had to be played by young men, adding to the comedy. The program warns, "No smoking allowed in the room."

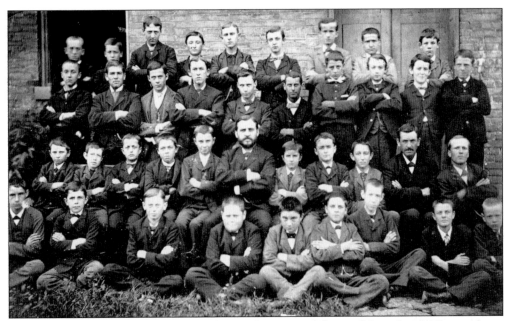

The male-only student body of YCA is posed in 1885 in front of the school. The academy admitted girls beginning in 1798 and probably taught them in coeducational classes until October 11, 1823, when the school was divided by sex into two classes and the girls' school moved to the second floor of the building. Much of the schooling of females at the time was with a view to the domestic duties of running a household.

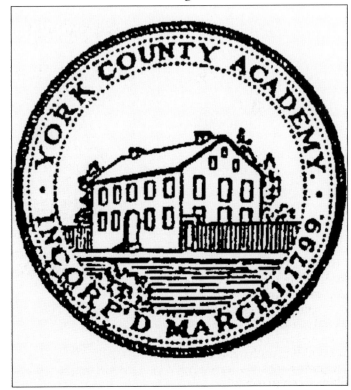

The seal of YCA was the first of a number of seals and logos used by York College of Pennsylvania (YCP) and its ancestral institutions. This YCA seal bears an image of the original school building.

13

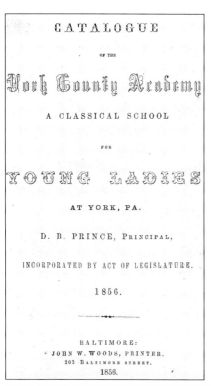

CATALOGUE

OF THE

York County Academy

A CLASSICAL SCHOOL

FOR

YOUNG LADIES

AT YORK, PA.

D. B. PRINCE, Principal,

INCORPORATED BY ACT OF LEGISLATURE.

1856.

BALTIMORE:
JOHN W. WOODS, PRINTER.
202 BALTIMORE STREET.
1856.

After a YCA catalog advertised a School for Young Ladies in 1856, 63 girls enrolled. But YCA principal George Washington Ruby argued that separate schools for the sexes and their close proximity caused him considerable "annoyance, care, and trouble" and the female department closed in 1871. A revival attempt in 1883 failed. It was not until a 1929 reciprocal teaching agreement with York Collegiate Institute (YCI) that girls' names reappeared on the academy rolls.

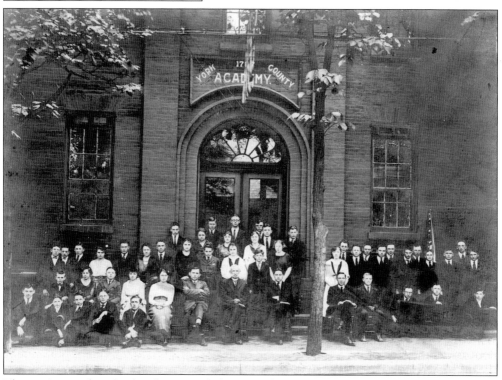

The entire student body of YCA and their teachers are shown here in the front of the academy in 1921.

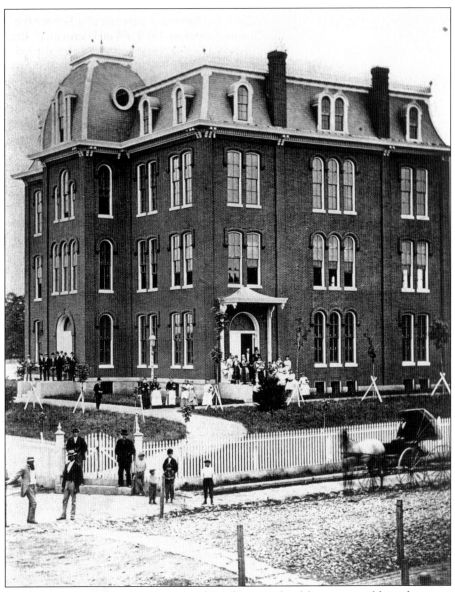

This is the oldest known photograph of the first YCI building, second lineal ancestor of YCP. YCI was founded and financed by prominent businessman Samuel Small in 1871. The four-story building at Duke Street and College Avenue in downtown York was incorporated by the Court of Common Pleas of York County on August 26, 1873, opened its doors to 60 boys and 46 girls on September 15, 1873, and was dedicated November 3, 1873. YCI promised instruction in "Christian culture." Pupils went into the classical, scientific, or commercial course, or young ladies' department. Classical and scientific courses offered a level of education comparable to two years of college work. Rev. Dr. James McDougal Jr., YCI's first president and instructor in religion, Latin, and Greek, is standing in the open doorway at the side of the building in the center of the photograph. He is outlined by the dark background of the open door. At his side, with the high hat, is Professor Lyon. Ladies at that doorway in this 1874 photograph are likely faculty members, according to the chronicles of C. H. Ehrenfeld, penned June 14, 1928.

Samuel Small, founder of YCI and president of the board from 1873 to 1885, was inspired to build a private preparatory school because of his close association with Rev. Robert Cathcart, a Presbyterian clergyman, and their shared concerns about the ideas of Charles Darwin that were beginning to spread. Small hand-picked most of his institute's trustees. His wife, Isabell Cassat Small, selected and donated 2,500 volumes to stock the library of the new school. The couple also established a scholarship fund for ministerial students accepted by the Presbytery of Westminster.

The official seal of YCI shows 1871 as its founding date and likely was the date that construction began. Limestone rock for the foundation and clay for the bricks that were made on site came from excavation of the "quarter square of ground" at Duke Street and College Avenue.

First Annual Commencement.

YORK

Collegiate Institute,

JUNE 19th, 1874, AFTERNOON AND EVENING.

COMPLIMENTARY.

A complimentary ticket to the first commencement staged by YCI was among the memorabilia contributed to the archives of YCP by YCI alumni.

The first commencement at the new YCI was an exciting time for the school, which had proved successful from the start. More than 100 pupils enrolled the first year, followed by 135 the following year. A later catalog, for the 1877–1878 school year, announced that three of YCI's first graduates "entered without condition the Junior Class at Princeton."

FIRST

ANNUAL COMMENCEMENT

OF THE

York Collegiate Institute,

YORK, PENN'A.

Afternoon and Evening, June 19th, 1874.

## Programme.

### AFTERNOON.

PIANO DUETT—"Night Blooming Cereus,"
MISSES DAVIS AND SMALL.

PRAYER.

SONG—Greeting,   -  -  -  FULL CHORUS.

LATIN ORATION,   -  -  -  -  Cicero.
MR. WM. J. NES.

RECITATION—"The Battle,"   -  Schiller.
MR. JNO. W. LOWE.

RECITATION—The Charcoal Man,   -  Trowbridge.
MR. JNO. C. REED.

PERI WALTZES,
MISSES HIESTAND AND CROSS.

RECITATION—"Ivry,"   -  Macauley.
MR. A. T. STEWART.

READING—Hiawatha's Wooing,   -  Longfellow.
MISS C. JACOBS.

PIANO SOLO—L'Argentine,
MISS DAVIS.

RECITATION—Eve of Waterloo,   -  Byron.
MR. L. D. PARSONS.

READING—Dream Life,   -  -  Ik Marvel.
MISS N. G. KIRK.

GREETING SONG,   -  -  -  Original.
FULL CHORUS.

RECITATION—"Betsey and I are out"   -  Carleton.
MR. C. W. MIFFLIN.

RECITATION—"Betsey and I are in,"   -  Carleton.
MR. H. EPPLEY.

HOME SWEET HOME—Piano Duett.
MISSES MAGGIE SMALL AND ANNIE STEWART.

Commencement exercises for the first class to matriculate from YCI consisted of a long program of readings, music, and recitations by the young honorees during the afternoon and evening of June 19, 1874. The musical portions included several piano duets in addition to presentations by the YCI chorus. The full program, which served in part to demonstrate the lessons learned at the school to all who might be interested, is displayed here.

### EVENING.

PIANO DUETT—Beviamo,   -  -  Ernani.
MISSES SMYSER AND HIESTAND.

CHORUS OF SPRING,   -  -  Kalliwoda.
FULL CHORUS.

READING—Faithless Nelly Gray,   -  Hood.
MR. JNO. C. SCHMIDT.

Address, HON. THOMAS E. COCHRAN.

MUSIC—Piano Solo, Auld Lang Syne,
MISS DAVIS.

READING—Miss Mac Bride,   -  -  Saxe.
MISS E. J. BOND.

READING—The old clock on the stairs,   Longfellow.
MISS DAVIS.

MUSIC—Piano Duett,   -  -  Bellini.
IL PIRATA—CAVATINA.

READING—Summer in a Garden,   -  Warner.
MR. WM. H. McCLELLAN.

RECITATION—"Virginia,"   -  Macauley.
MR. H. C. NILES.

ANNIVERSARY JUBILEE,   -  -  Bliss.
FULL CHORUS.

FRENCH RECITATION—"La Marseillaise,"
MR. A. S. NILES.

READING—Songs of Seven,   -  -  Ingelow.
MISS C. V. BRESSLER.

ALBUM PRESENTATION.

READING—Evening Prayer,   -  -  Hemans.
MISS M. SMALL.

PIANO DUETT,   -  -  LA PARISIENNE.

BENEDICTION.

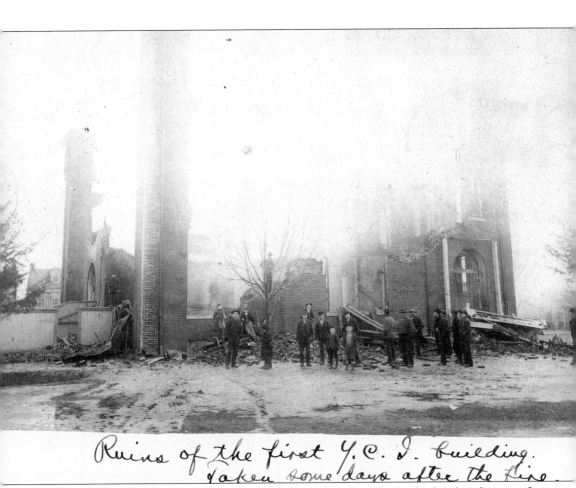

*Ruins of the first Y. C. I. building. Taken some days after the fire.*

Two events roiled YCI in 1885. First its founder, Samuel Small, died July 14 at the age of 86. Five months later, the night of December 7, the school he had built was destroyed by fire, leaving only the ruins pictured above. Losses were put at $50,000. The fire was believed to have started in the cellar where the furnace was located. The regular janitor was sick and a substitute not as familiar with the workings of the furnace was in charge. Others thought the fire might have started in the basement laboratory. Volunteer firemen fighting the blaze were handicapped by a shortage of hoses and a lack of sound hoses, prompting an appeal for a paid fire system in York. Displaced students resumed classes within a few days at the "providentially" vacant York Hospital and Dispensary Building on West College Avenue near Water Street. Classes were held there until the new building was completed.

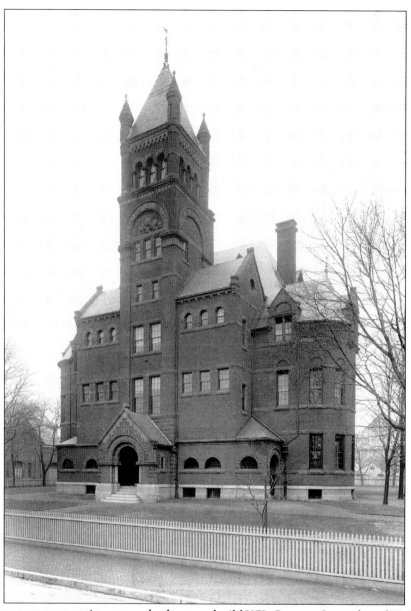

There was never a question as to whether to rebuild YCI. George, Samuel, and W. Latimer Small, three nephews of the late founder, pledged their financial support for the $70,000 rebuilding project. Construction began on the same site in 1886, and the building was dedicated March 15, 1887. The new design by architects J. A. and Reinhardt Dempwolf isolated the laboratory and furnace to reduce the risk of fire. The Richardsonian Romanesque architecture had a Gothic feel, liberal stonework, and earth-toned colors. It was red brick with Hummelstown Brownstone trimming. The school was four stories high with a central six-story tower topped by a pyramid roof and four small spires. The entrance opened to Memorial Hall, a "marblesque" granite great hall with two stairwells leading to the second floor, which held a large general schoolroom and an auditorium that seated 400 to 500. Cassat Library, Philosophical Hall, and the Music Room were on the third floor. The fourth floor was a gymnasium.

Quickly needing more space because of the growing number of pupils it was attracting, YCI in 1897 added a laboratory wing to the main building. Records show that the cost of the wing was $360.

The whitewashed Continental Congress doorway (now at the York County Heritage Trust Museum) was the original stoop of the old York County Courthouse, built in 1756 and razed in 1841. That courthouse is where the Articles of Confederation were drawn up in 1777. The doorway was procured by Samuel Small for YCI's third-floor Music Room and then became a permanent fixture of the elegant Memorial Hall until the building was razed in 1962.

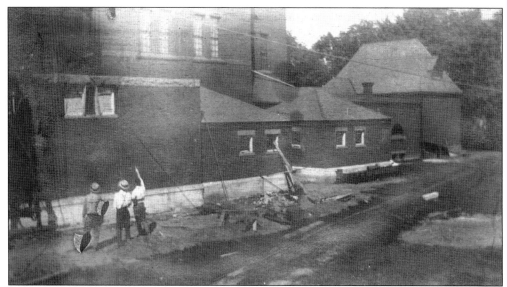

In 1916, construction got underway for the "College Avenue Gym" of YCI. The cost of the new gymnasium was put at $12,067.

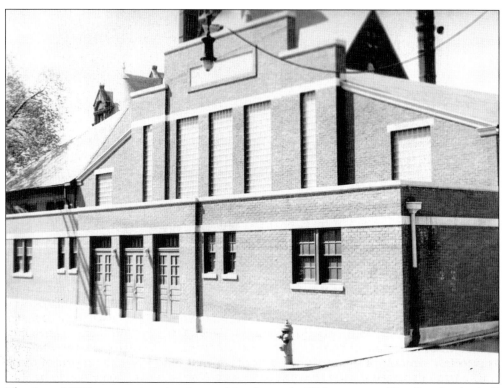

The "new" YCI gymnasium is pictured in the early 20th century. The first basketball game was staged here December 12, 1916. When the downtown York Junior College (YJC) building was razed in 1962, the gymnasium was spared and became the Voni B. Grimes Gym to be used by inner-city basketball leagues.

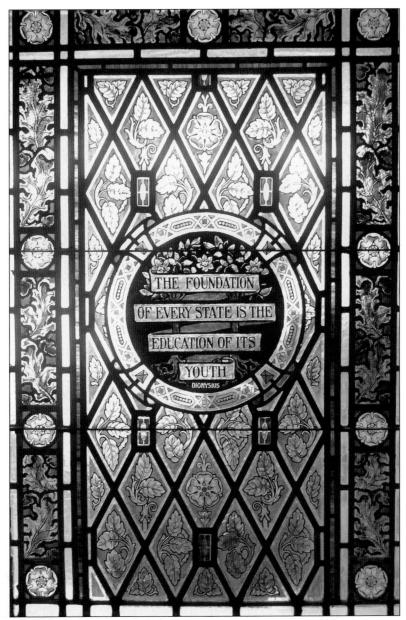

Among the treasures bequeathed to YCP by virtue of its history is a collection of 23 stained-glass windows salvaged by workmen when the old YCI/YJC building was torn down. The windows are the work of J. Horace Rudy (1870–1940), famed designer and master craftsman who, with three siblings, established Rudy Brothers' Stained and Leaded Glass Company in York. In 1978, the YCP Women's Auxiliary saw the windows as priceless symbols of the institution's heritage and underwrote the repair of those cracked and damaged during removal or storage. The windows, some dating back to the 19th century, today can be found in Schmidt Library, Iosue Student Union, Brougher Chapel, and the president's home. This window, behind the Information Services Desk of Schmidt Library, quotes Dionysius: "The foundation of every state is the education of its youth."

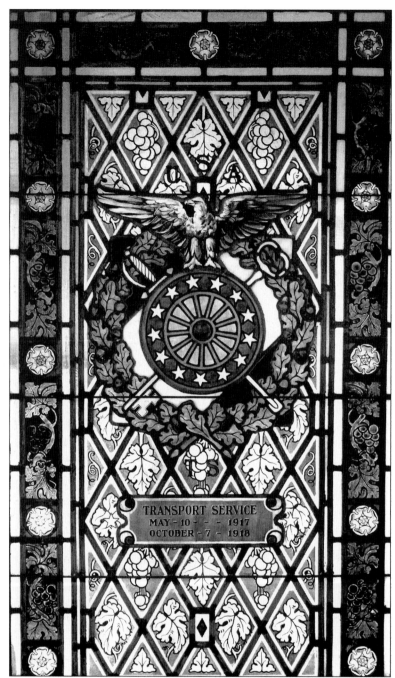

This stained-glass window, also the work of famed designer and master craftsman J. Horace Rudy, shows an eagle and the Transport Service seal. It was commissioned in memory of 1884 YCI graduate Nettie Smyser's son Lt. Martin Smyser Weiser who died in World War I. Her son was in the Transport Service. This window, along with other stained-glass windows, can be found in the lobby entrance to Schmidt Library. The stained-glass work of the Rudy Brothers' Stained and Leaded Glass Company gained renown throughout Pennsylvania, Ohio, and into the Carolinas.

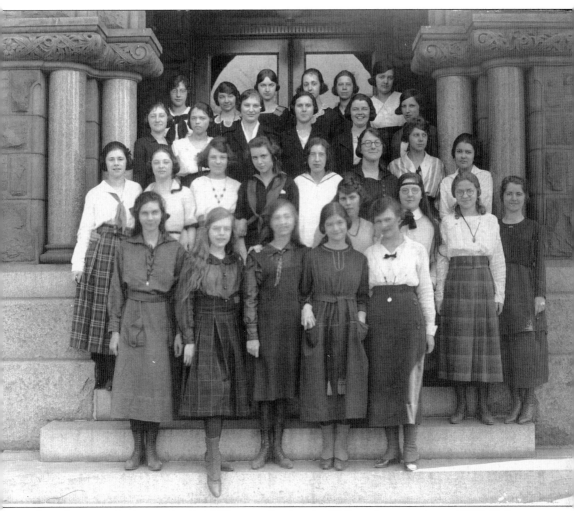

This photograph shows the Ariel Literary Society in 1919 at the entrance to YCI. Helen Bolton and Isabella Beard, in the second row, are the only names on the photograph. The Ariel Literary Society was directed by the ladies of the faculty to deepen student interest in literature, science, art, and music. Its other stated purpose was to instruct members in the parliamentary procedures required to conduct meetings. It had a philanthropic mission as well, devoted primarily to the Visiting Nurse Association and Red Cross. The criterion for admittance to the Ariel Literary Society was based upon scholarship and dignity of conduct. Literary societies in general began to emerge about 1830 on college campuses. Then the concept filtered down to preparatory schools and other institutions of learning. Literary societies also gave students an opportunity to write, read, and discuss their original prose and verse at meetings of the group. They were an extension of the educational mission of their institutions for probably a century until other school organizations began to vie for students' time and attention.

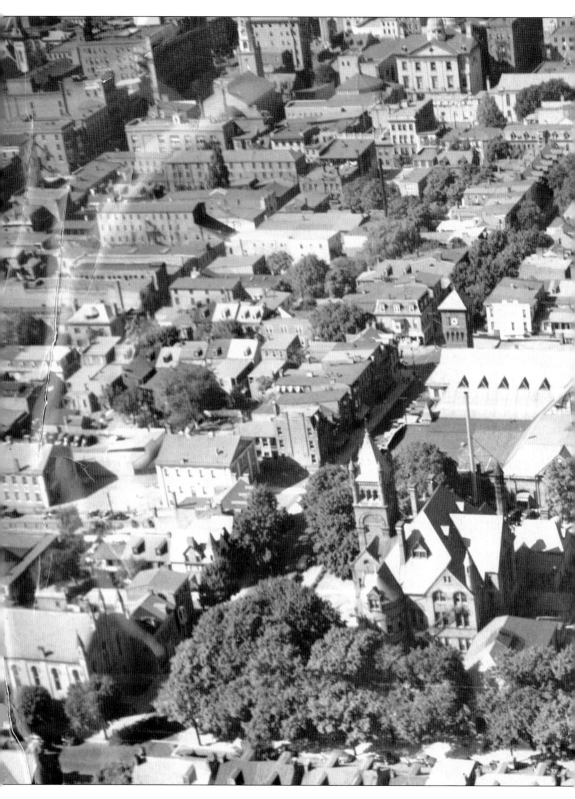

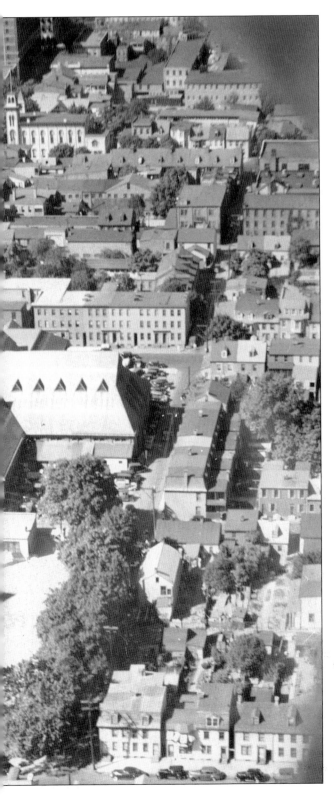

This 1946 aerial photograph shows the building that at the time was home to YCI and YJC. The gymnasium also can be seen on the small plot at Duke Street and College Avenue that the building had occupied in downtown York since 1886. The six-story tower of the structure overlooked the city for 76 years. When growing enrollment at the college forced the move from the tight quarters downtown to a new campus, this York landmark was sold and then torn down. The demolition took place over two days, February 22 and 23, 1962, and was quite controversial. It was considered "a sacrilegious deed," according to one writer. The spot where the building once stood became a play lot.

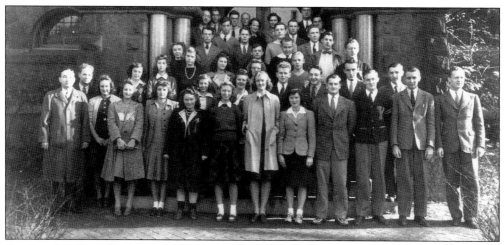

On October 3, 1941, the first class of 42 freshmen entered the newly chartered Junior College of York Collegiate Institute. Several months later after Pearl Harbor, all but 10 of the male students were lost to the armed forces. Pictured here are, from left to right, (first row) mathematics professor Mr. Whiting, Lois McWilliams, Eleanor Oberdick, Gloria Sipe, Mary Jane Yohe, Dorothy Ann Jenkins, Zoe Fulton, Dorothy Crone, William Kline, John Getz, Jack Lease, and English professor Mr. Kelly; (second row) junior college president Lester Johnson, Bette Jane Metzler, Lois Gilbert, Patricia Book, Jane Swartz, Dale Geesey, Donald Stump, Harold Stambaugh, and John Charleston; (third row) Edythmae Leithiser, Dorothy Leeper, Nina Arnold, Dorothy Sneeringer, Doris Cook, Dale Suereth, and Jack Barton; (fourth row) Wendell White, Curtiss Allison, David Hoke, Frederick Page, and Paul Gilbert; (fifth row) Daniel Street, language professor Dr. Hilde Jaeckel, Wendell McMillan, Richard Goodling, and John Brandt; (sixth row) presidential assistant Dr. Paul Z. Rummel, Alvin Stambaugh, history professor Vincent G. Matter, dancing instructor Mrs. Dempwolf, Robert Olewiler, and Carlyle Mitzel.

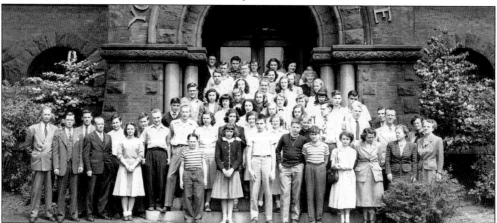

Here is the student body of YCI in 1945. The following year, the junior college operating in the building began to offer "Courses for Penn State Freshmen Enrolled at the York Junior College." A consequence of the agreement with Penn State impacted YCI. Penn State would not grant accreditation while both the junior college and the secondary department were being conducted under the same roof. On December 4, 1947, trustees discontinued YCI's secondary school. With more space, the junior college expanded its curriculum.

# *Two*

# THE PRESIDENTS

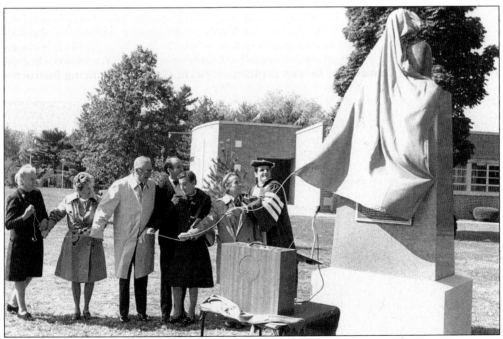

Founder's Day weekend, October, 14–15, 1977, was marked by the unveiling of a bust of Rev. John Andrews sculpted by Zoel Burickson, a YCP faculty member, pictured second from right next to YCP president Robert V. Iosue. Others from left to right are descendents of Andrews—Mrs. Alfred Bissell of Greenville, Delaware; Mrs. Martin Dwyer of Syosset, New York; Henry B. Thompson of Reisterstown, Maryland; and Rodman Ward Jr. and his mother, Mrs. Rodman Ward, of Wilmington, Delaware.

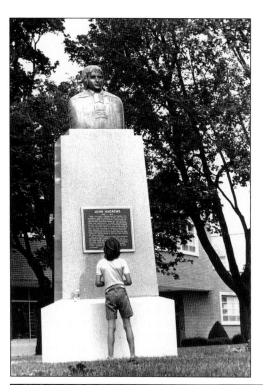

The bust of Rev. John Andrews, shown in a prominent spot on the main campus, was a gift to YCP from the artist and sculptor-in-residence Zoel Burickson and descendants of Reverend Andrews—Georgiana Harris Shober, Henry Flagler Harris, and John Andrews. The base for the sculpture was given by Raymond S. Noonan, a contractor and college trustee. Reverend Andrews was the Episcopal clergyman who started the earliest ancestral school from which YCP evolved.

# JOHN ANDREWS
## 1746 – 1813

YORK COLLEGE'S LINEAGE CAN BE TRACED TO A CLASSICAL SCHOOL OPENED IN THE LATE 1770s BY THE REVEREND JOHN ANDREWS. CONTINUING THE EDUCATIONAL HERITAGE BEGUN BY THAT SCHOOL WERE THE YORK COUNTY ACADEMY, INCORPORATED IN 1787; THE YORK COLLEGIATE INSTITUTE, FOUNDED IN 1873; AND YORK JUNIOR COLLEGE, ESTABLISHED IN 1941. AS YORK COLLEGE OF PENNSYLVANIA SINCE 1968, THIS INSTITUTION STILL IS IMBUED WITH THE HIGH STANDARDS OF SCHOLARSHIP, SERVICE AND INTEGRITY WHICH MARKED THE LIFE AND CAREER OF JOHN ANDREWS.

THIS STATUE, BY YORK COLLEGE'S SCULPTOR-IN-RESIDENCE, ZOEL BURICKSON, IS A GIFT TO THE COLLEGE FROM MR. BURICKSON AND DESCENDANTS OF JOHN ANDREWS – GEORGIANA HARRIS SHOBER, HENRY FLAGLER HARRIS, AND JOHN ANDREWS

The inscription on the sculpture of Reverend Andrews traces YCP's lineage to the classical school taught by Reverend Andrews in the late 1770s and acknowledges the artist and donors of the sculpture.

The first principal to truly put his mark on YCA was George Washington Ruby (1850–1880). He instructed some 2,000 students in that period. In 1858, Ruby founded the York County Normal School as part of the academy to train elementary grade teachers. The 10-week course advertised that it was not about pedagogy, but about helping teachers become thoroughly familiar with the subject they were teaching. This branch of YCA operated until 1921, when state teaching certification requirements could no longer be met by YCA's modest facilities, and the academy could not compete with the Pennsylvania State Teachers Colleges.

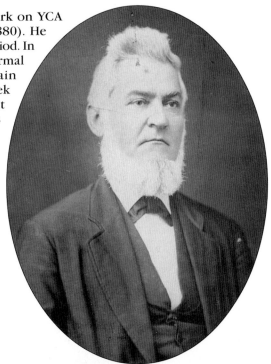

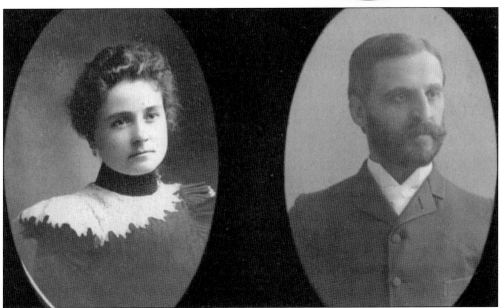

George Washington Gross (1856–1935), seen with his wife, the former Gertrude Merriken, in their 1886 wedding photograph, became YCA principal after the death of George Washington Ruby. Gross was affiliated with the academy 60 years. He was principal 1880–1885, tutored or taught until 1893, then again became principal until 1898. He became president of YCA's board of trustees in 1927, serving until his death in 1935. During his tenure, YCA added a "modern" steam heating system and flourished with 70 pupils, plus 125 in the York County Normal School.

David H. Gardner (1847–1924) conducted the York County Normal School on the second floor of YCA for 35 years. He was YCA principal 1887–1893, resigning to become county superintendent until 1905, then again became academy principal from 1906 until 1923. Gardner, according to the 1952 History of York County Academy, had a habit of taking an idler by the hair with the admonition, "Do not procrastinate, my boy, do not procrastinate." George Washington Ruby, George Washington Gross, and Gardner epitomized the academy through longevity in their posts, their personalities, and their high moral principles.

When YCI opened its doors September 15, 1873, Rev. Dr. James McDougal Jr. was chosen as its first president and an instructor in religion, Latin, and Greek. He held that post until his death in 1892. McDougal declared at dedication services that YCI would educate women as women, held to ideals portrayed in the Scriptures, and not train them to be lecturers, ministers, doctors or "manlike women of any name." Their education would be geared toward lives as homemakers and contain "a little mathematics, less Latin, no Greek, a little metaphysics, and no logic." An emphasis on religious instruction applied to both sexes.

Rev. Dr. Eliakim Tupper Jeffers resigned a Presbyterian pulpit to become the second president of YCI. He served 22 years, also teaching religion, psychology, and Latin, until his death on November 18, 1915. His tenure brought renewed interest in athletics and expansion of the college preparatory school to include grades 1 through 10. Jeffers was active in civic affairs and in 1912 became president of York County Historical Society. Following his death, he lay in state in Memorial Hall where his body was viewed by hundreds. The entire student body attended services in YCI's auditorium.

Dr. Charles Hatch Ehrenfeld, head of the Scientific Department at YCI since 1887, became the third president in 1916 and first layman elected to the position. He served until 1928, when he was succeeded by Wilbur R. Lecron, who was both YCI headmaster 1928–1934 and YCA principal 1929–1934. In addition to Ehrenfeld's YCI duties, he was chemist of the York Water Company and York Manufacturing Company; elected to York Select Council under the old form of city government in 1906 and was its president 1908–1914; chaired the Health Department until 1908; and founded and was first president of York Engineering Society.

Dr. Lester F. Johnson concurrently headed all institutional predecessors of YCP. He was first president of YJC (1941–1952), last principal of YCA (1935–1952), and the last headmaster of YCI (1935–1948). A YCI mathematics teacher, he became a YCA instructor with the 1929 reciprocal teaching agreement. He led both until YCI dropped its secondary program in June 1948, then spearheaded its conversion to a junior college. He later became mayor of Rehoboth Beach, Delaware. Former Pennsylvania governor George M. Leader was one of Johnson's students at YCI.

When Johnson resigned the presidency of YJC in 1952, the trustees chose Dr. Robert G. Dawes as his successor. Dawes, at the time of his election, was chief of education and cultural relations for Bavaria. Dawes was inaugurated September 29, 1952, and served until 1956. He reorganized the college structure, established faculty committees, and began to attend all meetings of the trustees. Student enrollment rose from 260 to 506 in his four years, and the college began to consider relocating. Dawes pushed for charter changes to grant associate degrees and to plan for a four-year college.

When classes began in September 1956, Dr. J. F. Marvin Buechel, previously president of Everett Junior College in Washington State, was the new president of YJC. His brief administration ended with his death from a heart attack February 22, 1958. But during his tenure, the trustees, on March 15, 1957, gave notice that they would exercise their option signed January 1956 to purchase the Out Door Country Club property for a new campus.

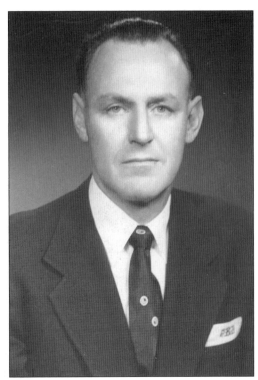

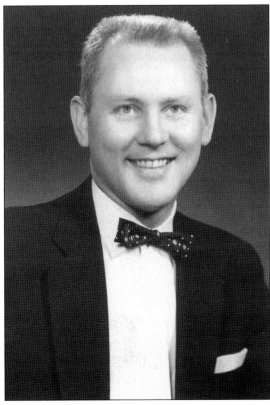

Dean Charles E. Rollins, noted for his bow ties and pipe, twice became acting president of YJC. The first time was late 1956 when Dawes became ill and until Buechel arrived on campus; the second time was between Buechel's unexpected death and the arrival of Dr. Ray A. Miller. Rollins resigned as dean in 1962 to become president of a new junior college in Florida.

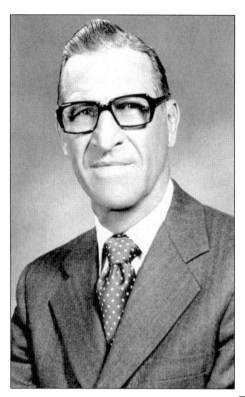

Dr. Ray A. Miller, a vice president and dean of Fairleigh Dickinson University, became president of YJC in October 1959. Coinciding with his arrival, the final installment on the new campus site was paid, and the title to the land conveyed. A $1 million building campaign got underway, and for a time, the business of running the college was divided between the old campus and the new. Miller then directed transformation of the school from a junior college to a four-year, baccalaureate-granting institution, which included developing an academic ranking system and pay scale for its educators that became effective September 1, 1965. From 1959 to 1968, Miller was president of YJC and from 1968 to 1975, his title was president of YCP. Under his watch, in September 1968, the curriculum offerings were changed to ensure that all students came in contact with the major areas of man's knowledge—English, history, languages or studies in a non-Western culture, mathematics, science, and physical education.

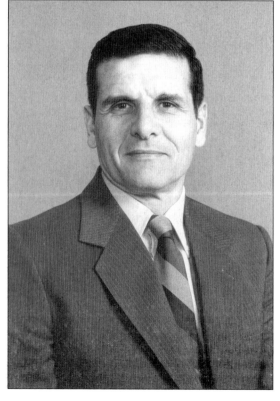

Dr. Robert V. Iosue, dean and later vice president of the C. W. Post College of Long Island University, became president of YCP in 1976. In his 15 years at YCP, new dormitories were built, the library and cafeteria were expanded, classrooms were added, and a computer center was constructed. Iosue considers the crowning achievement of his term to be the chapel on campus. The bell tower in the chapel garden was named for his wife, Christina. Iosue received his bachelor's degree from Fitchburg State College in his native Massachusetts, was a lieutenant in the U.S. Marine Corps, received a master's degree in fine and industrial arts from Columbia University, and another master's degree in mathematics plus a doctorate in mathematics from Adelphi University.

With the arrival of Dr. George W. Waldner in 1991, YCP embarked upon a series of ambitious strategic planning and fund-raising efforts that resulted in tremendous growth and expansion of the campus, its facilities, and its academic programs. Land was acquired for the West Campus where new facilities for engineering and nursing as well as a new sports center transformed aged industrial sites. Waldner came to YCP from Wilkes University where he was vice president for academic affairs and a professor of political science. Previously he was provost at Oglethorpe University in Atlanta. He holds a bachelor's degree from Cornell and his post-graduate degrees from Princeton. He attended the Inter-University (Stanford) Center for Japanese Studies in Tokyo and received a certificate in advanced written and spoken Japanese language.

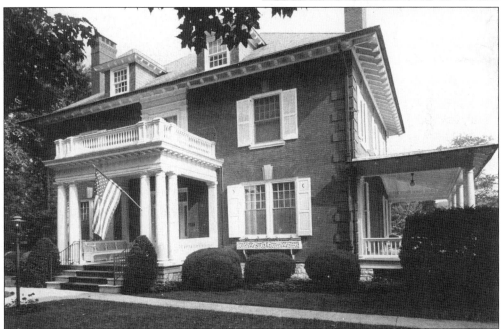

This home on Springettsbury Avenue, designed by architect J. A. Dempwolf, was first occupied by Kate Small, widow of YCI trustee W. Latimer Small, then by Mr. and Mrs. Charles Bear for 30 years, then by Mr. and Mrs. S. Walter Stauffer, and then by their daughter and son-in-law, Mr. and Mrs. Robert Skold. When YCP gained ownership, it became the presidential residence for the institution.

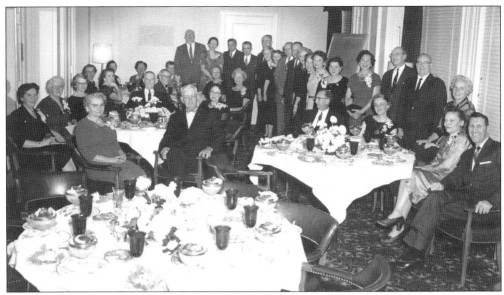

YCP president Ray Miller, lower right, hosts a combined class reunion November 1, 1959, for 1918, 1919, and 1920 YCI alumni. The others are, from left to right, Margaret Moore (Steinmetz), Emma Dawson (teacher), Mrs. Horace Grove, Eva Sweitzer (Hanning), Marian Cook, Mrs. Fred Rupley, Mrs. Malcom Read, Elizabeth McConkey (Gailey), Mr. Hanning, Fred Rupley, Mary Weiser (Barnitz), Harry Rochow, Horace Grove, Eleanor Ditty (teacher), Hannah McConkey (Small), Josephine Beck (Hoff), Mrs. Harry Rochow, Stewart Warner, Bruce Grove, Dr. Garvey, Marion Seitz (Mrs. Garvey), Helen O'Reilly, Elmer Anstine, Charles Zeigler, Ruth McLean (Zeigler), Mrs. Bruce Grove, Helen Baird (Mrs. Saylor), Mary McFall (Rains), Melvin Campbell, Mrs. Ray Miller, Elizabeth Baird (Sullivan), Walter S. Ehrenfeld, James Knipe, Ellen Eyster (Campbell), Mrs. W. S. Ehrenfeld.

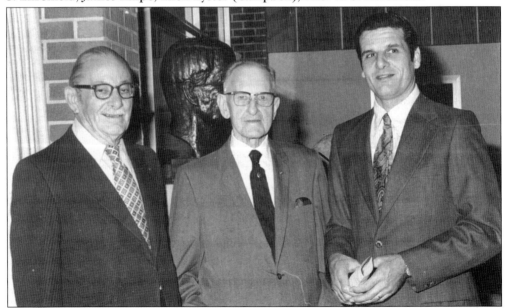

YCP president Robert V. Iosue is shown here with YCA alumni Chester Miller, left, and Emory Sietz, center. The occasion was the Founders' Day celebration on October 14–15, 1977.

# *Three*

# LEAPS OF FAITH

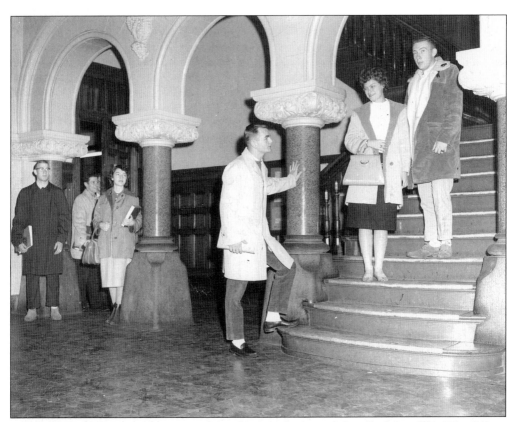

YJC students are shown here in 1961 in the grand Memorial Hall of the old YCI building, home of YJC since 1941. Memorial Hall was a "marblesque" granite great hall with two stairwells leading to the second floor of the 1886 building. A portrait of YCI founder Samuel Small, not visible here, hung over the large fireplace in the room. This candid shot became a yearbook photograph. Dorothy Kaley, standing on the left, and Herb Cully, on the left in the black coat, are the only students identified.

THE JUNIOR COLLEGE
OF
THE YORK COLLEGIATE INSTITUTE
YORK, PENNSYLVANIA

This 1941 catalog cover announces the beginning of the transition from a college preparatory school to the Junior College of York Collegiate Institute. The following year, the catalog displayed the name as "York Junior College of the YCI" and by 1943–1944, the catalog simply put "York Junior College, York, Pennsylvania" on the cover, although the first inside page made it clear that it was the Junior College of York Collegiate Institute.

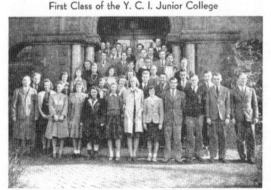

## The York Collegian

VOL. 1 — No. 1     THE Y. C. I. JUNIOR COLLEGE, YORK, PENNA.     DECEMBER 12, 1941

### Pres., Assistant Give Background In Interviews

Pres. Johnson Graduate Of Dickinson College; Formerly Navy Member

Mr. Lester F. Johnson, President of our Junior College, was born in Lewes, Delaware. He received his elementary and secondary training in Lewes and upon its completion, he matriculated at Dickinson College. At Dickinson, he was vice-president of the Y. M. C. A., and later president. Vice-president of the literary society, member of the student senate, business manager of the college paper and president of the senior class. The sports he participated in were: class basketball, cross country track, tennis and intra-fraternity baseball.

At the close of his junior year at Dickinson, Mr. Johnson enlisted in the navy. The navy, however, sent him back to Dickinson to complete his college course and he was graduated with his class receiving his Bachelor of Arts degree. For the next four years he was a member of the navy on the reserve list, but was not called upon for active service. He attended Jefferson Medical School for

First Class of the Y. C. I. Junior College

Front row, left to right: Mr. Whiting (professor of Mathematics), Lois McWilliams, Eleanor Gierdisk, Gloria Sipe, Mary Jane Yohe, Dorothy Ann Jenkins, Joe Fulton, Dorothy Croue, William Rhue, Jean Getz, Jack Lease, Mr. Kelly (English professor), Second row: Mr. Johnson, (President of the Junior College), Belle Jane Mctaire, Lois Gilbert, Patricia Book, Jane Swartz, Dale Grovey, Donald Money, Harold Stambaugh, John Charleston, Third row: Edythene Leibhart, Dorothy Leeper, Nina Arnold, Dorothy Sweetmore, Doris Cook, Dale Surrich, Jack Barton, Fourth row: Wendell White, Curtiss Atkson, David Bohn, Frederick Page, Paul Gilbert, Fifth row: Daniel Street, Mr. Jacobsi (professor of German and French), Wendell McMillan, Richard Goodling, John Brandt, Sixth row: Dr. Ramuel (assistant to the President), Lester Johnson, Alvin Stambaugh, Mr. Muller (History Professor), Mrs. Botqwolf (Dancing Instructor), Robert Gleuiler, Carlyle Mitzel.

Open House Precedes    **From The President**    *Students To Enact*

### Student Council Completes Draft Of Constitution

Makes Provisions For Representative Council Ratification Due Dec. 15

Final draft of the constitution of the student government of the York Junior College has been completed and this document now awaits ratification by a majority vote of the student body before December 15, 1941. The constitution provides for a student council comprising the cabinet and two representatives from each of the freshman and sophomore classes. The cabinet consists of the president, vice-president, secretary and treasurer of the sophomore class. Each class will elect a boy and a girl representative to serve a term of one year.

The constitution sets forth that the student council initiates all legislation pertaining to the welfare of the student body with the approval of the faculty board. It is also stated in the document: "The duties of the student council shall be to create, recommend, maintain, and regulate social functions and activities of the student body; to investigate any appeal made to it by any student, such appeal to be in writing and presented

The December 12, 1941, front page of the *York Collegian's* first issue carried a photograph of the first class of 42 freshmen enrolled in the new Junior College of York Collegiate Institute. The school soon lost most male students to the armed services. The war years forced many private schools to close their doors, but the college and its secondary schools did not curtail programs. By 1947, 70 percent of the students were veterans.

The 1950–1951 YJC catalog, its tenth, used the junior college name on the cover along with a drawing of the building it occupied. Inside the catalog the school was described as "York Junior College of the York Collegiate Institute-York County Academy." By the 1959–1960 catalog, it was just York Junior College. The first associate degrees in arts and sciences were awarded to 31 YJC sophomores on June 3, 1955.

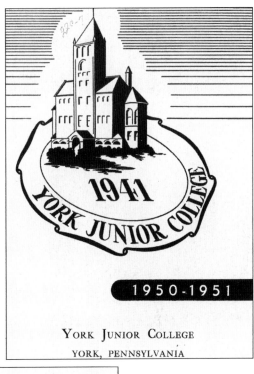

The early official seal of YJC, the third and last institutional predecessor of YCP, identifies it as an arm of YCI. Yearbooks from the 1950s show a different seal bearing the name York Junior College, an image of the building's tower, the words "eruditio ducat," and the years 1787, 1941, and 1873, representing the three institutions that called the tower building home.

41

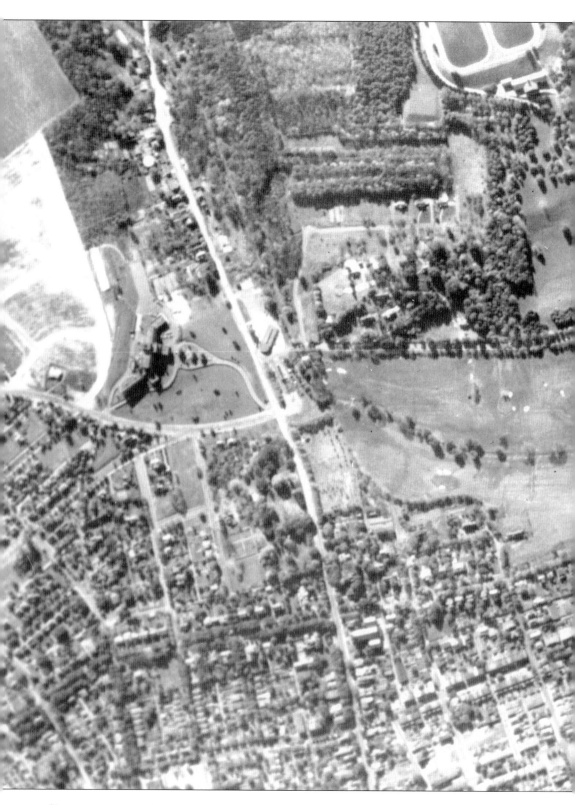

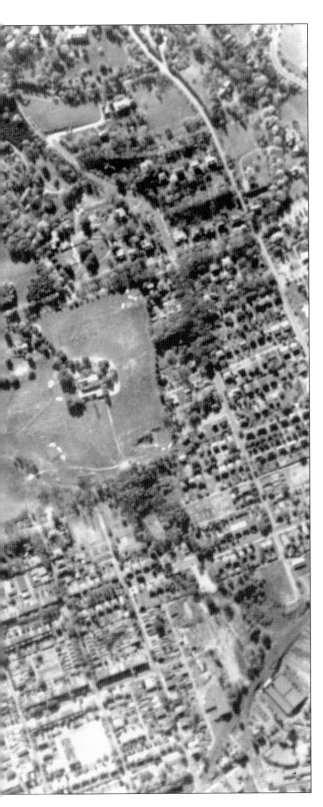

An influx of veterans of World War II and the Korean War taxed the old downtown YJC building despite discontinuance in 1947 of YCI's secondary school and kindergarten programs. On March 15, 1957, trustees exercised an option to purchase the Out Door Country Club golf course for a new campus. The 57.5-acre property on the north side of Country Club Road cost $250,000. The college took possession October 1959, anticipating facilities for 1,000 day and boarding students and 1,000 evening and adult education students. This aerial photograph shows the new campus site as a golf course. White areas are sand traps. Tyler Run meanders through the property at the bottom. Basins that are part of York Water Company's processing system on the south side of Country Club Road are at the top of the photograph.

Charles Glatfelter (December 13, 1808–December 13, 1895) originally owned a farm that was on part of the land that is now YCP. He was the father of Philip H. Glatfelter, founder of P. H. Glatfelter Company and was the great-great-grandfather of Edward W. Glatfelter, donor of this photograph and a former YJC student. Edward designed a mace with the orange and white colors of YCI, the orange and black of YCA, and the green and white of YJC, which with his father, Dr. Edward A. Glatfelter, he presented to the college in 1961 in honor of Charles Glatfelter.

The golf course purchased by YJC included two buildings. This *c.* 1830–1860 farmhouse on Country Club Road, known as the "white house," was a caretaker's residence. It became YJC's Student Affairs Center and testing and guidance center in the early stages of development of the new campus site. The present administration building now occupies the spot.

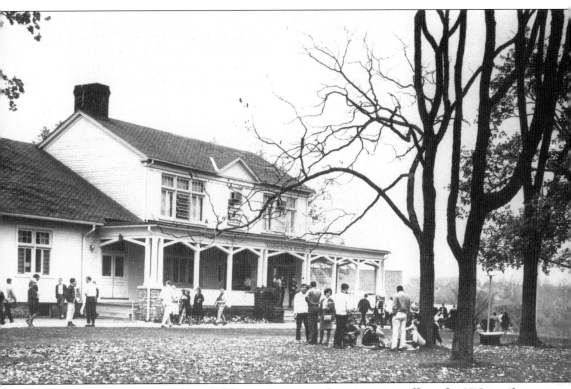

The Out Door Country Club's clubhouse became administrative offices for YJC until a new administration building was completed in 1966. The clubhouse is a modified relic of a Victorian mansion designed by York architect J. A. Dempwolf and first used in 1900. In 1928, the Out Door Club rented, and in 1945 purchased, the property from York Country Club, which had moved to a new location with more land. The clubhouse was destroyed by a chimney fire in 1934 and reconstructed. In its earliest days, a trolley car ran right up to the veranda of the clubhouse.

Surveyors plot new construction with YJC's temporary administration building in the background. YJC began preparing for groundbreaking October 7, 1957, opening an account known as the York Junior College Development Fund at York Trust Company. On September 22, 1959, Donald Gilbert of Associated Architects and Engineers submitted preliminary drawings indicating five stages of development of the new campus. A proposal to spend $100,000 renovating the old clubhouse was rejected.

YJC announces its arrival on Country Club Road with its name emblazoned on the side of York Hall, the first building erected on the new campus. Construction began June 1960 and was completed March 1961. The first floor had classroom space for 800 students. The second floor became the temporary library. By the 1961 spring break, all collegiate affairs except for athletics had been transferred to the new campus.

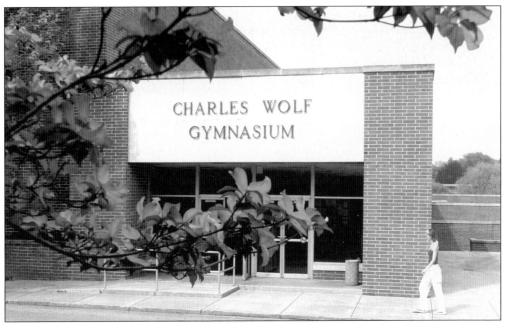

Construction of a gymnasium began in the spring of 1961 and was completed in December 1961. The National Baseball Hall of Fame's Brooks Robinson, third baseman with the Baltimore Orioles and formerly with the York White Roses, gave the dedicatory address January 12, 1962. The gymnasium seated 1,800 and also hosted concerts, lectures, and theater performances. The building contained classrooms and was headquarters for the college nurse. Its opening completed YJC's transition from downtown York to its new campus.

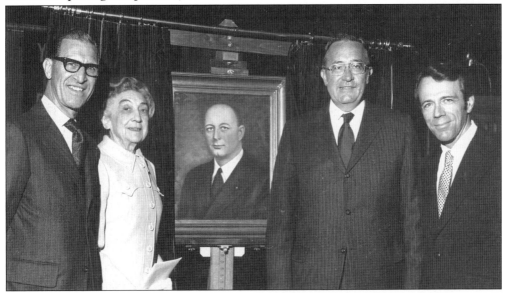

Wolf Gymnasium, the second new facility to be constructed on the new campus, gained an addition in 1969. At dedication ceremonies, flanking a portrait of Charles Beck Wolf (1891–1951), for whom the facility was named, are, from left to right, president Ray A. Miller, Frances Wolf (wife of Charles), Charles S. Wolf, and Dr. Carl Hatch. This "original" gymnasium was the project of Charles S. Wolf.

Housing for out-of-town students was a simmering issue, with trustees divided over whether dormitories were needed for a college established primarily for local students. Those in favor prevailed, and Springettsbury Hall, a dormitory for 130 women, was completed in the summer of 1963. Manor Hall, a men's dormitory for 280 students, was completed the following year. Previously non-commuters had to get rooms at the YMCA and local hotels.

It was the summer of 1966 and the worst drought on record in York County. Nevertheless YJC had a number of luxuriant and beautiful flower beds because dedicated gardeners carried buckets of water to the beds each day from the stream that crosses the campus. Springettsbury Hall is in the background.

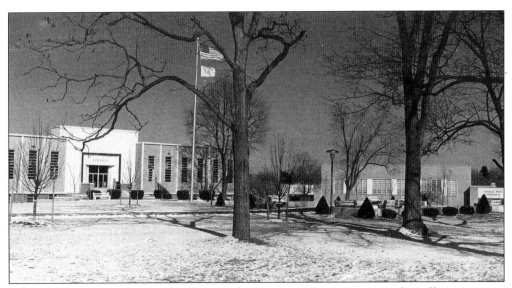

When admissions topped 1,000 in 1963, straining capacity in York Hall, a separate library building became essential. The new library had open house October 11, 1964. On October 3, 1981, it was dedicated to business leader and entrepreneur Henry D. Schmidt and his family. Schmidt previously was honored in 1979 with a namesake lecture series focusing on the American free enterprise system. A renovated Schmidt Library reopened in 2004 with new electronic resources and a wireless network. Books, media, bound periodicals, and electronic resources currently number close to 300,000.

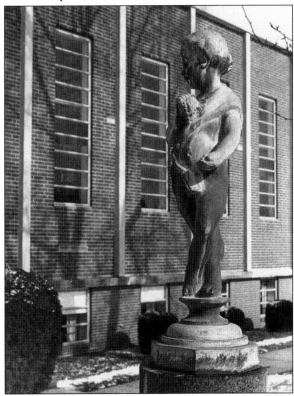

Four marble columns framed the entrance to the old YCI. A 1979 plaque states that they were donated by Purdon Smith Whiteley in honor of her graduating class of 1907. When the building was torn down in 1962, the columns were moved to the gardens at Mrs. George Whiteley's home, Box Hill, and mounted with the *Four Seasons* figurines. Today the columns and figurines grace the walkway to Schmidt Library.

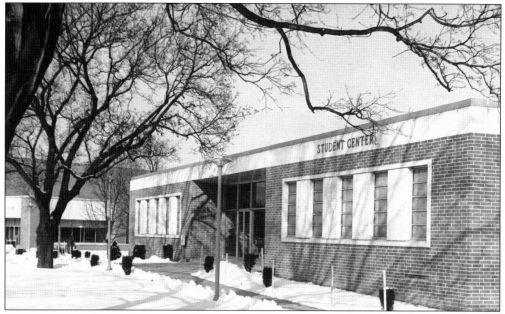

Construction of a student center began in 1965 at the same time as Manor Hall, a men's dormitory. The Student Center, later named for president Robert V. Iosue, contained a dining room, lounges, game rooms, snack bar, conference and study rooms, offices for student activities and publications, and college store. It temporarily served as headquarters for the top college administrators, including the president.

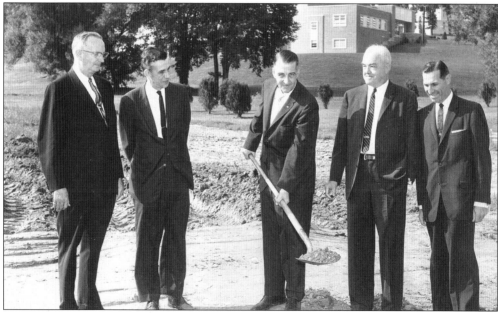

Groundbreaking became a regular occurrence as YJC built its new campus brick by brick. This 1960s photograph shows, from left to right, Mr. Seifert; Donald Gilbert, the architect for all the buildings rapidly turning the former golf course into a college campus; trustees Benjamin M. Root and John T. Robertson; and YJC president Ray A. Miller. This groundbreaking was for the tennis courts.

# *Four*

# TWO YEARS TO FOUR AND MORE

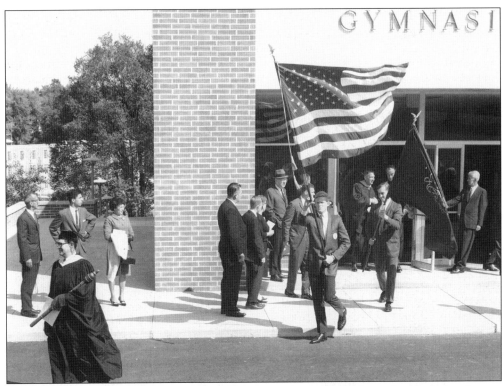

With six new buildings in use, the administrators and trustees decided that it was time for formal dedication ceremonies for the new YJC campus. The October 2, 1965, program began with an academic procession from the library across campus to the gymnasium. In this photograph, Bradley J. Culbertson, dean of admissions, leads the academic procession out of the gymnasium. Following him are two students, Jacob McCord of Limerick carrying the American flag, and John Frantz of Haverford with the Pennsylvania state flag.

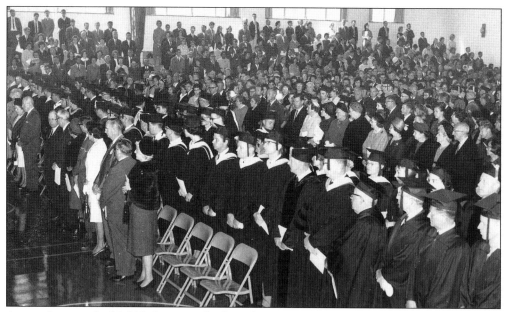

A capacity crowd of 1,800 distinguished academics, administrators, government officials, and friends filled the gymnasium for the dedication ceremonies of YJC on October 2, 1965. The York Junior College Choir, under the direction of Ralph Woolley, performed at the ceremonies. Parents' Day activities followed the ceremony.

Pennsylvania governor William W. Scranton, left, pictured with YJC president Ray A. Miller, delivered the keynote address at campus dedication ceremonies in 1965. Scranton, noting that dedications tended to celebrate the physical plant, reminded the audience that the greatness of any educational institution "rests upon the highly personal relationships between and among its faculty and students." He further predicted, "Another five years may see the establishment of a four-year college here."

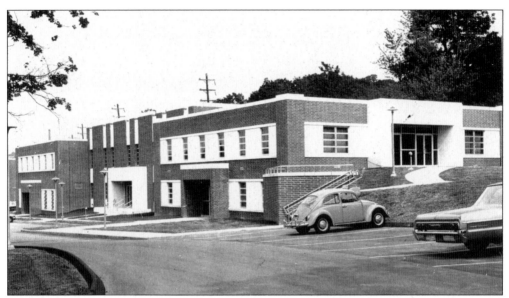

The physical expansion of YJC continued unabated following campus dedication ceremonies in 1965. A second dormitory, Penn Hall, opened near Springettsbury Hall in 1967. It housed 130 young women. Then groundbreaking ceremonies were held May 11, 1967, for the much-anticipated new administration building in this photograph, completed in 1968. The former Out Door clubhouse that had served YJC as temporary administration headquarters was razed.

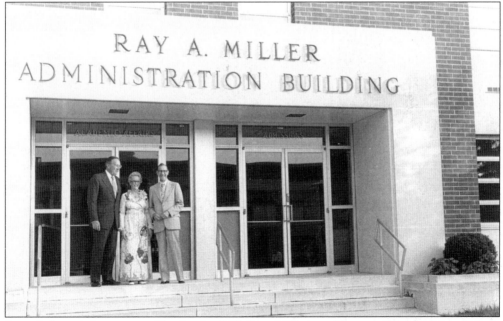

From left to right, trustee Charles S. Wolf, Cora Miller, and former YCP president Ray A. Miller stand in front of the administration building newly named in Miller's honor on August 22, 1976. Ray A. Miller served as the institution's president from 1959, when it was still a junior college, to 1975, overseeing its transition from a junior college to a four-year college.

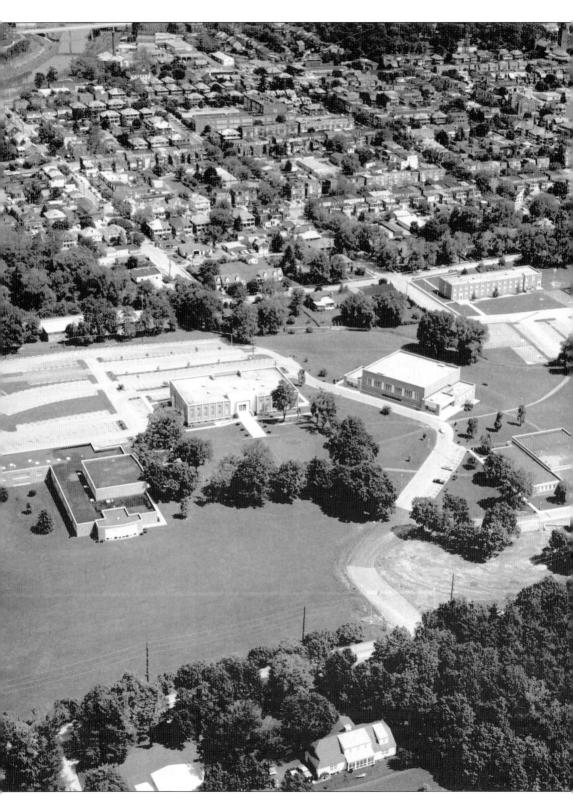

This aerial photograph of the YJC campus in 1968 clearly shows nine buildings. From left to right are York Hall, the first structure to be erected on the new campus; the library; the gymnasium; the student center; the administration building; and four dormitories to the right of the photograph. The ground remains torn up in front of the newly completed administration building in the foreground. The dormitories toward the back of the photograph along Springettsbury Avenue are Springettsbury Hall (later renamed Beard Hall) and Penn Hall. The ones to the right of the administration building and along Country Club Road are Manor Hall North and Manor Hall South. Manor Hall East and Manor Hall West would later be added to that dormitory area.

It is official. This 1968 announcement
graphically shows that the two-year YJC
has attained four-year, baccalaureate
degree–granting status.

*York* ~~*Junior*~~ *College of Penn- sylvania*

Mid-February's mail brought the good news from the Department of Public Instruction of the Commonwealth of Pennsylvania. Effective September 1, 1968, York Junior College will become YORK COLLEGE of Pennsylvania.

Approval to change the name and to offer four-year programs grew out of the recommendations of the Bureau of Institutional Studies and Services of the DPI. An evaluation team, representing the Bureau, studied the College last October.

Next fall's freshmen, the class of 1972, will be the first alumni of the four-year College. The complete junior year will be offered in the day school in the fall of 1970. However, some junior courses will be offered in the evening school every semester starting in the fall of 1968.

In addition, 13 two-year programs will be continued for associate degrees from York or for transfer to other colleges.

**Two Year Majors**
Biology
Chemistry
Education
  Elementary and Secondary
Fine Arts
  Music and Art
Languages
  English, French, Spanish,
  German, Russian
Marketing
Mathematics
Philosophy
Physics
Pre-Engineering
Religion
Secretarial
  Medical and Executive
Speech

**Four Year Majors**
Accounting
Behavioral Sciences
  Psychology and Sociology
Business Management
English
History and Social Science
Medical Technology

MARCH, 1968

**YORK** JUNIOR COLLEGE NEWS LETTER

The class of 1971 was the first four-year class to graduate from YCP. The class is shown here
assembling in the gymnasium. Philip H. Glatfelter III, local industrialist and descendant
of Charles Glatfelter, who once owned the land on which the campus was built, was
guest speaker at commencement exercises. In 1977, YCP granted Philip Glatfelter an
honorary doctorate.

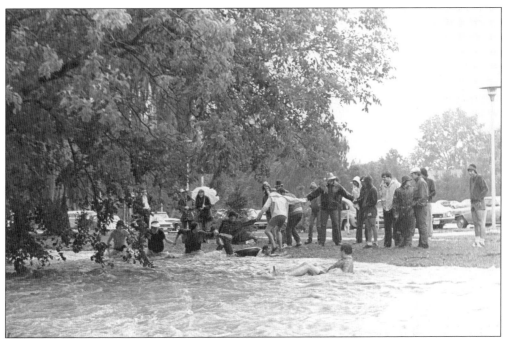

Students play in swollen Tyler Run after Tropical Storm Agnes walloped York County in June 1972. Tyler Run, normally a tranquil little stream that snakes through the YCP campus, was one of the many creeks and streams that overflowed their banks as the storm dumped 16 inches of rain on York County over five days. Flooding of Codorus Creek and backup from storm water sewers intensified the havoc.

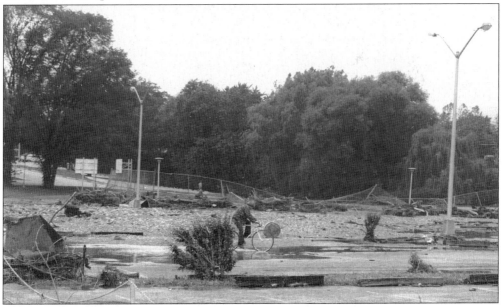

The camera surveys mangled fencing and other damage to the YCP campus in the aftermath of Tropical Storm Agnes's five-day visit to York County in June 1972. Flood waters locally killed five people, caused $10 million in damage in the city alone, and took out the county's last historic covered bridge.

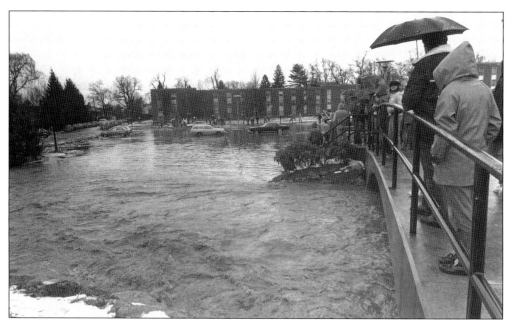

Entering YCP campus through the north entrance requires vehicles to drive through the shallow waters of picturesque Tyler Run. When the waters rise, the entrance is closed to traffic. A menacing and flooding Tyler Run is shown here in 1985. Thomas K. Gibson, telecommunications manager and chief engineer of campus radio station WVYC can recall seven or eight major flooding episodes over 35 years, and a dozen minor ones.

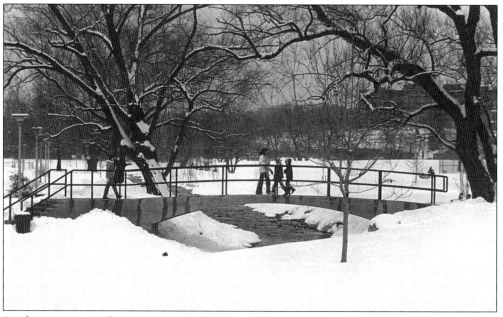

Students traverse the new Campbell Memorial Bridge over Tyler Run on a snowy day in 1979. The footbridge was named for long-time trustee Melvin Campbell at a ribbon-cutting ceremony on June 2, 1978. The bridge it replaced was built to get golfers across the stream when the campus was still a golf course. It was springy underfoot and students liked to make it bounce.

The Life Sciences building completed in 1974 was made possible by a campaign that brought in $1,750,000. Trustees Charles S. Wolf and Russel G. Gohn, respectively, were campaign chairman and vice chairman. Other trustees heading up campaign divisions included Melvin H. Campbell and Louis J. Appell Jr. In 2007 the Appell name was affixed to the Life Sciences building. The new Business Administration Center wing added in 1988 also is shown here.

Claire Winkler and Chip Rodgers stand in front of Melvin H. Campbell Hall, formerly York Hall. The first building to be constructed on the new Country Club Road campus site was renamed June 2, 1978, to honor the York industrialist and chairman of the board of trustees who contributed so much to the college.

Brougher Chapel was dedicated October 11, 1988. The former Schmidt home since the 1920s, it was conveyed to YCP on September 28, 1983, by Josephine Schmidt Appell. The chapel was named for YCP donors W. Dale Brougher and Nancy Brougher, who have a long, steady philanthropic commitment to the college.

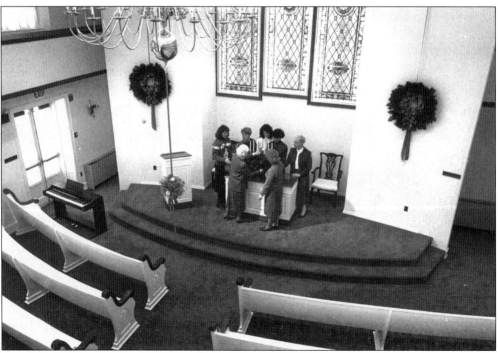

The interior of Brougher Chapel is shown here in 1988 when it was on a YWCA holiday tour. The three stained-glass windows were among those crafted by the famed J. Horace Rudy and salvaged from the old downtown "tower" building when it was razed in 1962.

The chapel bell and "praying hands" at Brougher Chapel are shown here on a wintry day. The Bell Tower in the chapel garden is named for Christina Iosue, wife of former YCP president Robert V. Iosue.

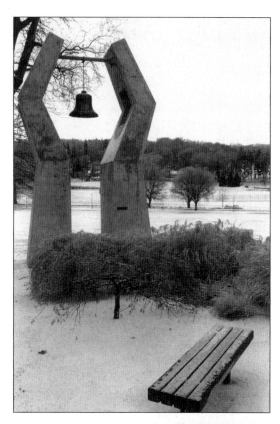

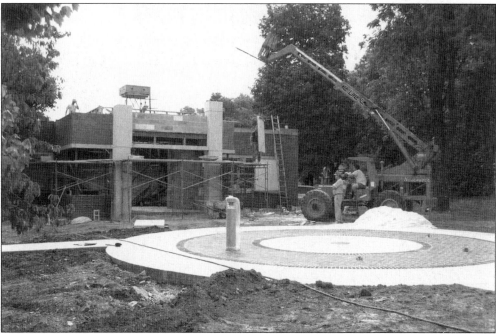

Workmen put a new facade on the administration building in 1992 and started work on a decorative concrete plaza at the front entrance to the building.

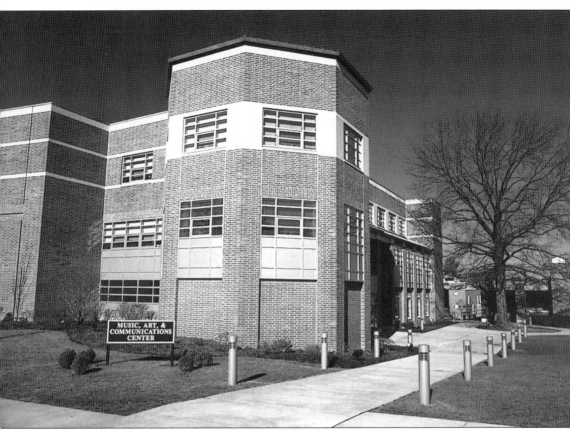

The Music, Art, and Communications Center (MAC building) occupies a prominent spot close to Country Club Road on the main campus. Its construction followed a capital campaign 1993–1996. The grand opening was held August 6, 1996. In 2006, the MAC building was named the Evelyn and Earle Wolf Hall to honor the parents of trustee and YCP benefactor Charles S. Wolf. The centerpiece of Wolf Hall is its adjacent exhibition halls, the Cora Miller Gallery and the Brossman Gallery, that offer exhibits, lectures, and workshops for the college and the public.

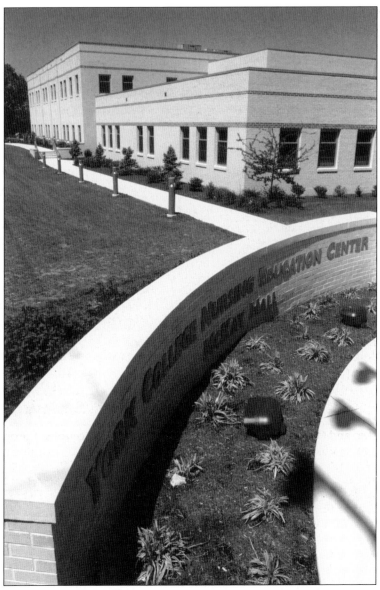

McKay Hall, the York College Nursing Education Center, is shown here on May 23, 2001. The Department of Nursing on Grantley Road offers bachelor of science and master of science degrees in nursing with clinical practicums. McKay Hall is situated on YCP's expanding West Campus, a reclaimed former industrial area between Grantley Road and Richland Avenue that was acquired in 1996. This building opened in the fall of 1999. It contains five laboratories that replicate actual clinical settings. Also on the West Campus are Grantley Hall, largely used for engineering programs; Grumbacher Sport and Fitness Center, completed in 2006 and incorporating the new Wolf Gymnasium; and Richland Hall, Spring Garden Apartments, Brockie Commons, and Country Club Manor Apartments, an older community apartment complex converted into campus housing. McKay Hall and nearby Grantley Hall are on a 23-acre tract that had been occupied by Teledyne McKay Corporation since 1919. A ribbon cutting for remodeled Grantley Hall was held October 3, 2005.

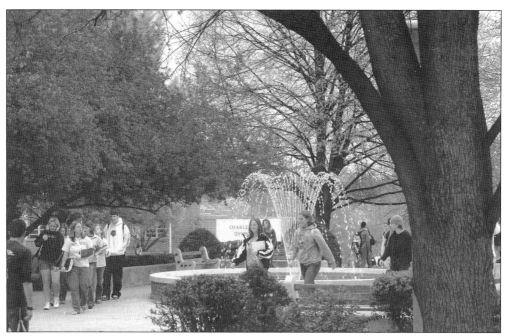

The fountain on the campus mall is dedicated to Raymond J. Melato, class of 1973. Melato was an administrator (1977–2004) and loyal alumnus who provided leadership for the planning and construction of many campus buildings and beautification projects. The campus mall is dedicated to Dr. Bruce A. Grove, YCI class of 1919, who was a YCP trustee and advocate of campus beautification projects.

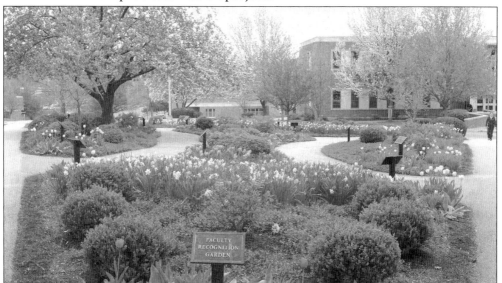

The Faculty Recognition Garden, located between the campus fountain and Iosue Student Union, provides a forum for YCP faculty members to be recognized for their contributions to the college. Presently a dozen faculty members' names are inscribed on plaques throughout the garden. Among the names are Dr. Dean L. Cheesebrough (1971–2002), academic dean and chairman of the education department, and former coach Jack C. "Jake" Jaquet (1960–1987).

# *Five*

# LESSONS AND BOOKS

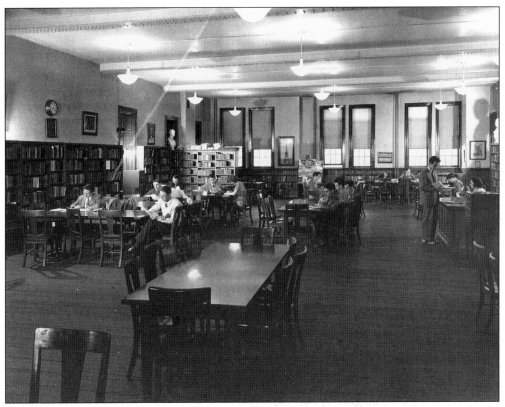

A quiet period in YCI's Cassat Library in the early 1940s is captured in this photograph. The YCI library opened in 1873 with 2,500 volumes donated by Isabell Cassat Small, the wife of YCI founder Samuel Small. A thousand of those volumes were saved the night of the December 7, 1885, fire that destroyed the first YCI building. The library was on the third floor of the rebuilt and grander YCI building that replaced the original school on the same downtown corner of Duke Street and College Avenue. The library much later acquired a valuable collection of 4,161 volumes donated by Francis Farquhar, local lawyer, industrialist, civic leader, and benefactor of YJC.

This photograph shows an 1898 physics laboratory in the YCI building in downtown York. No other information pertaining to the photograph could be found.

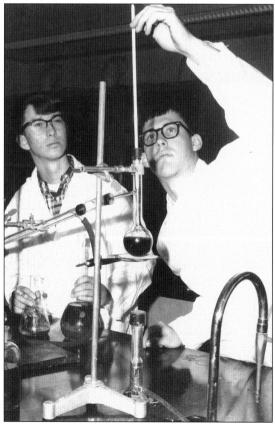

Gregory Schriver and Gary Paddison concoct some potions in this 1966 YJC chemistry class.

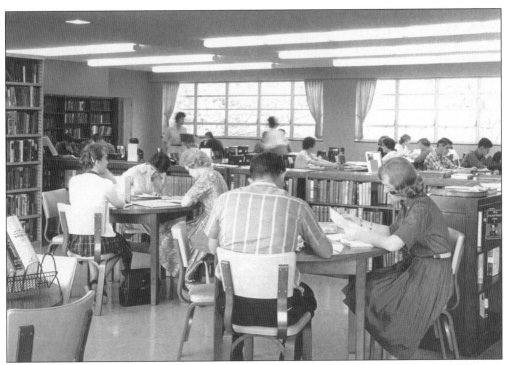

This photograph shows early 1960s students studying in the school library on the second floor of York Hall. Note the demure dresses on the girls. A dress code still held sway on campus and this code meant skirts, not slacks, for female students.

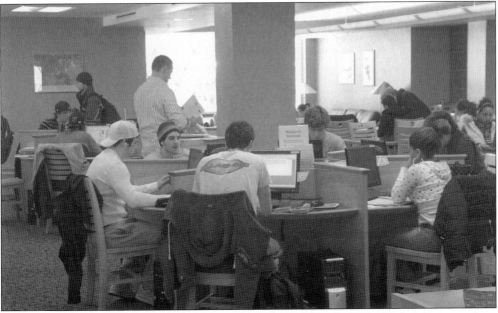

College students still go to the library to do research and study and libraries are still quiet, but most 21st-century college students can be found not in the stacks, but working at computer stations positioned on large, round tables on the main level of Schmidt Library.

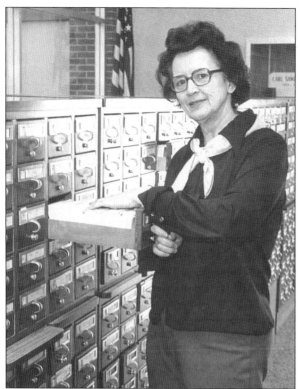

Remember the Dewey Decimal System? Margo Atwood, head librarian for many years at YJC and YCP, is caught in February 1978 in front of files that were the mainstay of the preelectronic library cataloguing system. In September 1968, the library began to change its classification system from Dewey Decimal to the Library of Congress system, bringing the collection into conformity with other college and university systems. The transition was completed over four years. In 1990–1991 the catalog was put online.

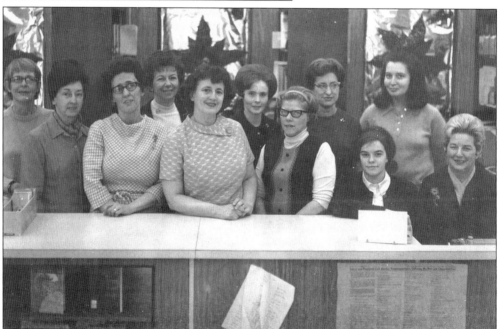

Head librarian Atwood is pictured here with library personnel on the new campus. Seen here are, from the left to right, (first row) Joyce Johnson, Josephine Roye, Dot Lagunowich, Atwood, Louise Rapper, Trudy Hildebrand, and Elsie Dressel; (second row) Jane Hiles, Elaine McKinstry, Judy Johnson, and unidentified.

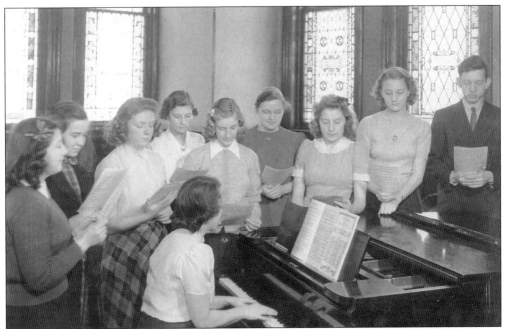

Singers gather around Elizabeth Anders at the piano in the YCI Music Room in 1940. The room contained several of the building's numerous stained-glass windows. The singers are, from left to right, Nancy Robinson, Jane Wilton, Miriam Kohr, Sara Jane Bennett, Nancy Bowen, Janet Garber, Betty McClean, Jean Motter, and Edward Garber.

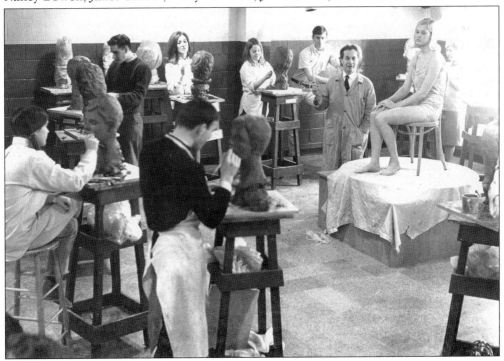

An unidentified student poses for an art class in 1967. YCP sculptor-in-residence Zoel Burickson is standing next to the model in the photograph.

A couple of 1966 YJC math students, Patrick Campbell and Elizabeth List, pay close attention to the explanation given by instructor Leon E. Arnold.

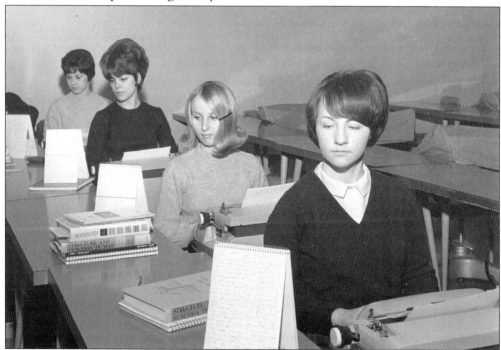

Pam Boll, Yvonne Lease, Joan Stabley, and Nina Gentzler take a shorthand and typing class at YJC in the 1960s. Typewriting was a standard offering first added to the courses offered by YCI in 1887. The Remington typewriter was the official "instrument" adopted for classroom use by YCI.

An unidentified student checks over selections in the YJC bookstore in the 1960s.

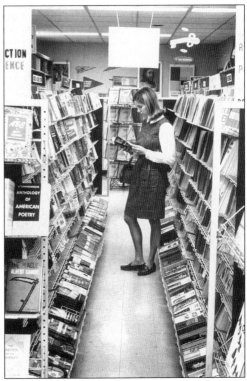

President Robert V. Iosue hosts new YCP faculty members in 1976. They are, from left to right, (first row) Florence Ames, Edward Smith, Annette Logan, Janice Smith, Paul Diener, Ronald Greenberg, and Iosue; (second row) Terrence Farrelly, Themba Sono, Melvin Kulbicki, Archibald How, C. Thomas Walters, Dana Myers, and Keith Peterman.

Foreign-born teachers on the faculty at YJC meet in October 1966 to talk about their experiences. Pictured are, from left to right, Dr. Khanna and Mrs. Sheth of India, Mr. Murog of Russia, Miss Livingston of Scotland and Alejandro de Vanguardia of Spain.

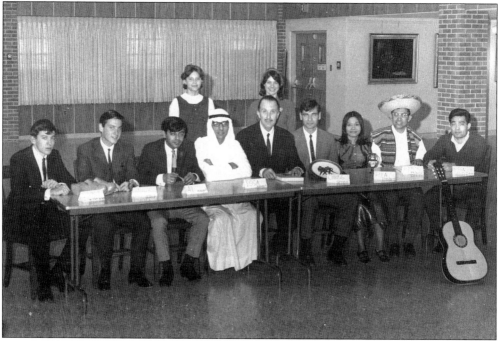

Foreign exchange students attending YJC in the early 1960s participate in a panel discussion. Seated are, from left to right, Joost, Larry, Al, Issa, Alejandro de Vanguardia, Chriss, Pia, Ramon, and Spencer. The two students standing in back are unidentified.

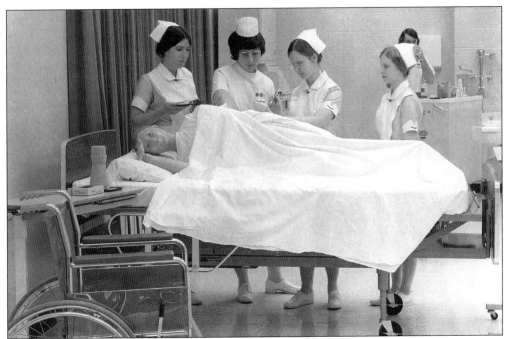

Student nurses at YCP practice technique with a mannequin during a practicum in the 1970s. The college in 1975 entered into a teaching affiliation with York Hospital School of Nursing that led to the college developing programs leading to bachelor of science and master of science degrees in nursing as well as special programs for registered nurses and licensed practical nurses.

Physical education for girls at YCI focused on correction of posture and physical weakness noted by the school's physician. Girls participated in swimming, tennis, volleyball, fencing, and badminton. A girls calisthenics class is shown in this undated picture, probably from the 1930s.

YCI boys do a synchronized stretch during a calisthenics class in the gymnasium. The school catalog explains that gym classes will focus on apparatus work and games to develop rhythm and coordination. Boys also had varsity teams in basketball, baseball, and tennis; but the catalog makes it clear that "the school does not consider the winning of games as of paramount importance."

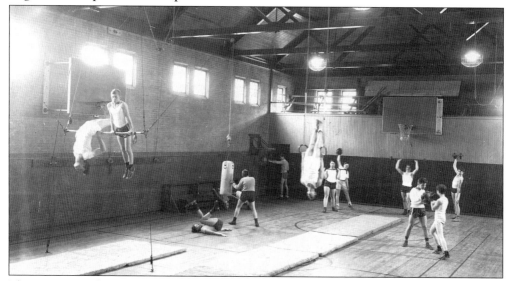

This 1939 or 1940 photograph shows Al Yoder on the high bar facing the camera; George Appell at the punching bag with his back to the camera; George Williams in black trunks with a barbell; Gibson Smith in white trunks, back to the camera, boxing with Larry Allen in black trucks; and John Baker behind Williams with one hand barbell. At the far right are probably Lester Johnson, with the one-hand barbell and Joe Kindig in black trunks with the barbell over his head. Identifications were provided by S. A. Yoder, class of 1944.

A YJC physical education class enjoys an outdoor session on a fine day in spring.

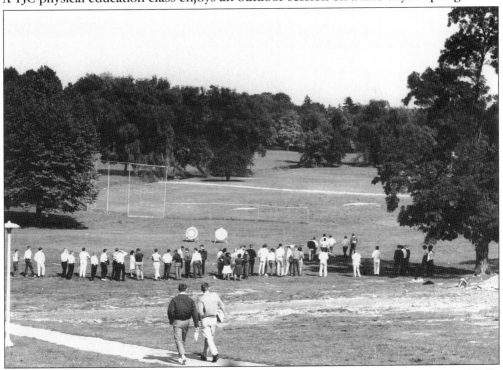

YJC physical education offerings included archery, golf, bowling, swimming, and folk, square, and social dancing. In this photograph, a 1964 archery class takes aim.

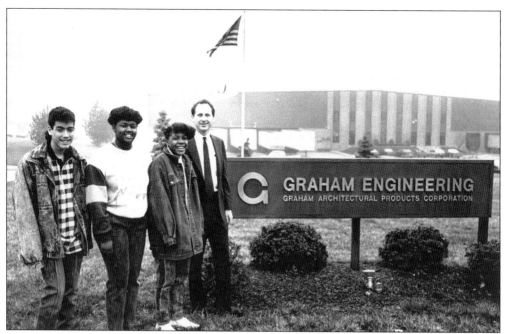

YCP has built a strong relationship with community industries and businesses. Shown at Graham Engineering are students who in April 1989 participated in the YCP Opportunity Program for York High School students aspiring to attend college. Seen here are, from left to right, Jose Colon, Martella Preston, Cicely Dalton, and mentor Al Blakey.

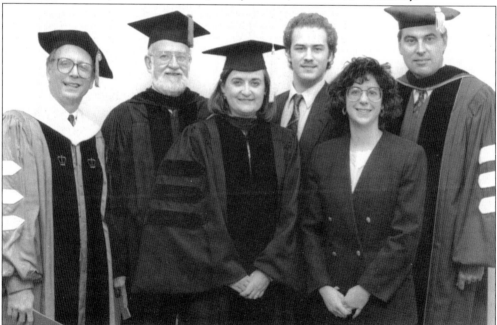

Two new members of the Alpha Chi Honorary Society at YCP are shown here in the fall of 1992. They are, from left to right, Dr. Stephen Wessley, Dr. William DeMeester, Dr. Carolyn Mathur, students Christopher Knisely and Jill Stoner, and Dr. George Waldner, YCP president.

# *Six*

# SPORTS THROUGH THE AGES

Baseball waxed and waned as a sport at YCI. This 1902 juniors baseball team had a four-legged mascot, pictured here. Games were played with nearby schools on the "old reservoir" lot on South Queen Street near Harding Court. Players in this photograph are not identified.

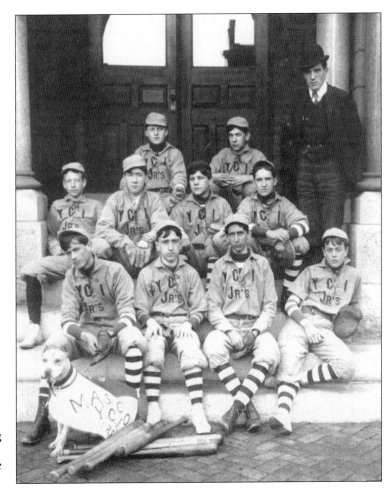

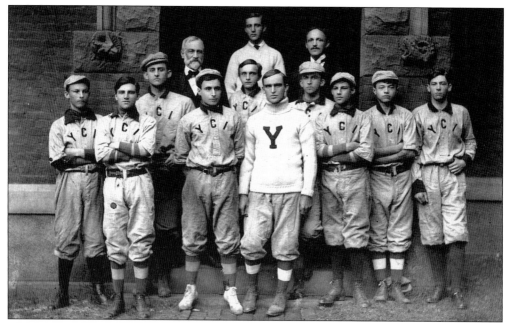

This 1890s team is one of the earliest baseball teams at YCI. Players in the photograph are identified in this way: Top, Arnold, Prof. Eliakim Tupper Jeffries on the left, with the beard, and another professor next to him; then from left to right, Horning, McLeod, McNeil, Reider, Fidler, Throne, Dise, Diehl, Hershey, and Green. By 1915, YCI had a championship team that for the first time beat the considerably larger York High School by a score of 2-1.

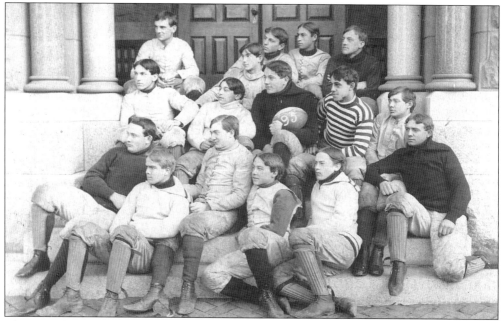

The 1895 football squad of YCI relaxes on the steps of the school. The photograph was donated by Jacob DeHoff, who got it from his aunt Dora Cline who was the daughter of YCI graduate Nelson Cline, of the class of 1895.

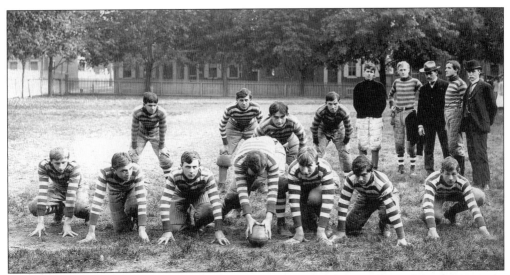

The YCI football team of 1902 scrimmages on the school grounds in this photograph. Fred Dempwolf is identified as being "on the end." The two professors standing on the side are Prof. R. Z. Hartzler and Prof. Albert B. Carner. Before 1900, annual games were played against York High School. YCI dropped football either after the 1905 season or the 1912 season when the coaches decided that the boys were too light and inexperienced to withstand the "buffeting" received in games. YCI apparently did not field a team again until the 1920s.

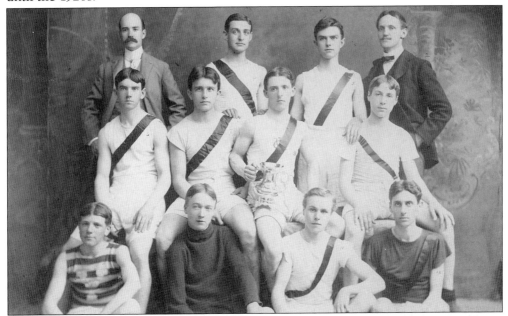

The YCI Athletic Association is pictured in June 1899 with a trophy. Those in the photograph are: Dr. C. H. Ehrenfeld, Professor R. Z. Hartzler, Arthur L. Jones, Lloyd Stevens, E. C. Thomas, Joseph Fisher, H. Kennard, Fred Yost, H. Eisenhart, Charles Dempwolf, Charles Walker, and R. Garrison. There was no information about the sport or event rewarded by the trophy. Generally sports were thriving in the early days. Relay teams, for example, competed regularly in the University of Pennsylvania Relay Carnival.

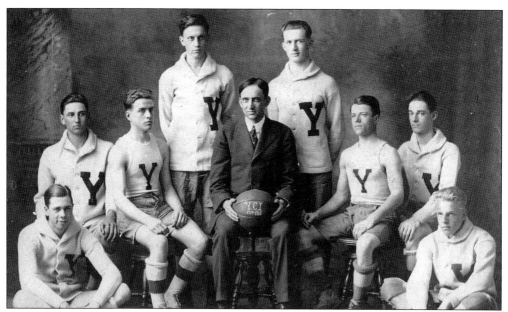

This photograph shows the 1914–1915 YCI boys basketball team, from left to right, (first row) George Williams and Philip Emerton; (second row) Willis Hauser, Henry Spangler, professor and coach E. D. Holt, Leonard Miller, and Harry Musser; (third row) Walter Shuler and George A. Goodling. Basketball became popular in 1909, and YCI, with no gymnasium at the time, erected wood basket supports in the rear yard where it was possible to play on two courts at one time. Home court to YCI was the Knights of St. Paul Hall on East Jackson Street and later the Coliseum (Valencia dance hall), where the longer floor winded players.

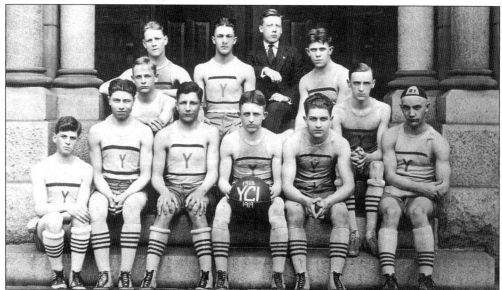

The 1918–1919 YCI basketball photograph identifies some team members as Sam McCoy, Gus Sommenan, Charlie Weiser, Campbell, Yingler, Bruce Grove, Charles Zeigler, Louis Fox, and Vick Pollack. By 1920, YCI was becoming a basketball powerhouse. The 1920–1921 team was undefeated. In 1924, YCI captured the Eastern Pennsylvania Prep School League title.

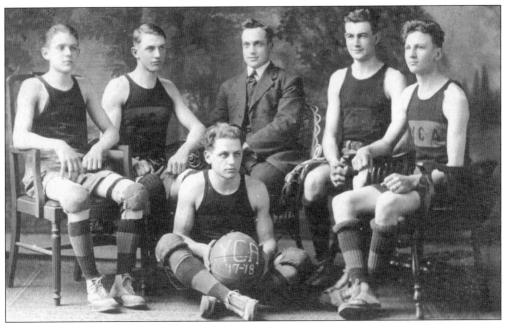

The 1917–1918 basketball team of YCA is pictured here. Seated in back are, from left to right, Ramsay Taylor, Bill Fink, "Danny" Klinedinst (the coach and teacher of math, history, and Latin), Raymond Culbertson, and Millard Gladfelter. Seated is Lester Gingrich.

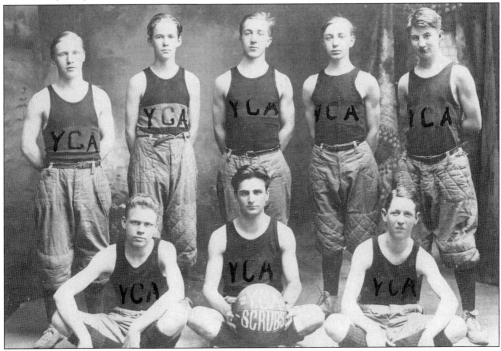

This 1913 photograph simply identifies these boys as the YCA basketball "scrubs." The early basketball teams rented St. John's gymnasium for practice. In 1912, the 125th anniversary fund, amounting to $6,000, was used to erect and equip a gymnasium at the rear of the school lot. In 1914–1915 the "scrubs" defeated YCI 13-10.

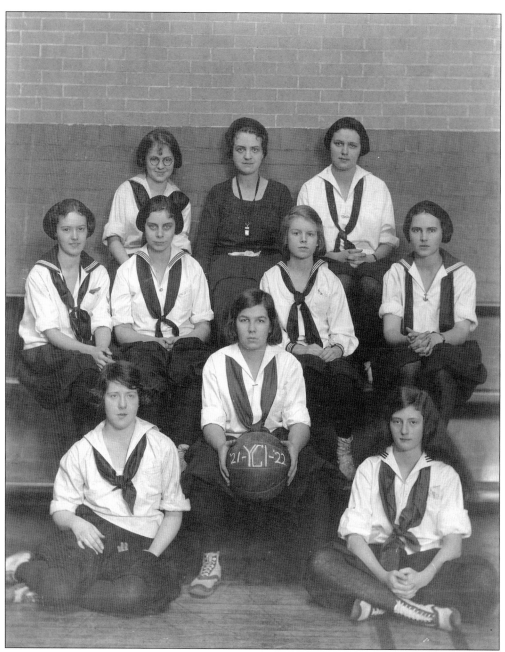

The YCI's girls basketball teams developed a reputation for their quickness on the court. The 1921–1922 team is pictured here in their uniforms. From left to right they are (first row) Polly Sitler, Elizabeth Bear (holding the ball), and Florence Hoff; (second row) Mary Gotwald, Helen Paxton, Louise Frick, and Frances Polack; (third row) Clara Hartley, Miss Rights, and Esther Stiles. The girls played in the basement storeroom of the Rosenmiller Building.

YCI student and basketball player Ellen Eyster carried these cards in 1929–1930. One got her into YCI basketball games. The other extended to her "junior" golf privileges at the Out Door Club on Country Club Road, which YJC would purchase 30 years later as its new campus site. The 1929–1930 team on which Eyster played defeated most rival high schools and prep schools. Lester F. Johnson was the coach.

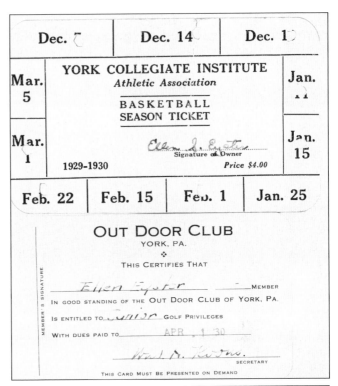

| Dec. 7 | Dec. 14 | Dec. 1? |
|---|---|---|
| **Mar. 5** | **YORK COLLEGIATE INSTITUTE** *Athletic Association* **BASKETBALL SEASON TICKET** | **Jan. 11** |
| **Mar. 1** | *Ellen J. Eyster* Signature of Owner — 1929-1930 — Price $4.00 | **Jan. 15** |
| **Feb. 22** | **Feb. 15** | **Feb. 1** | **Jan. 25** |

OUT DOOR CLUB
YORK, PA.
❖
THIS CERTIFIES THAT

*Ellen Eyster* _____ MEMBER

IN GOOD STANDING OF THE OUT DOOR CLUB OF YORK, PA.

IS ENTITLED TO *Junior* GOLF PRIVILEGES

WITH DUES PAID TO_____ APR 1 '30 _____

*Wm. N. Koons.*
SECRETARY

THIS CARD MUST BE PRESENTED ON DEMAND

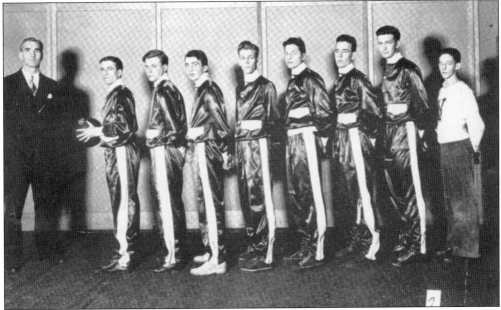

The 1936 YCI boys basketball team makes a fashion statement in this photograph. The team's flashy orange and white warm-up suits were believed to help YCI win games. "YCI looked like pros before the game began," according to Aylmer Yoder, 1944 YCI alumnus. Pictured from left are coach Archie McVicker, Jack Showalter, Luther Enderlin, unknown, Danny Peterman, unknown, John Ruppersht, Charles Shenberger, and Ted Culp, manager.

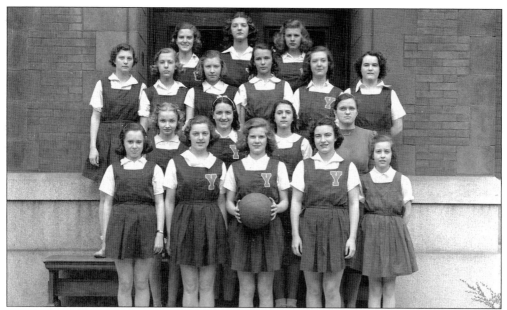

Members of the 1939–1940 YCI girls basketball squad are pictured here. They are, from left to right, (first row) Katherine Steacy, Julia Kurtz, team captain Mary Elizabeth Wisotzkey, Jody Schmidt, and Sally Whiteley; (second row) Janet Smith, Ruth Paul, Jean Williams, and Janet Garber; (third row) Sarah Jane Bennett, Connie Whiteley, Nina Ehrenfeld, Mary Hamilton McClellan, Charlotte Dempwolf, and Jane Morris; (fourth row) Marian Hartzell, Helen Fox, and JoAnn Wisotzkey.

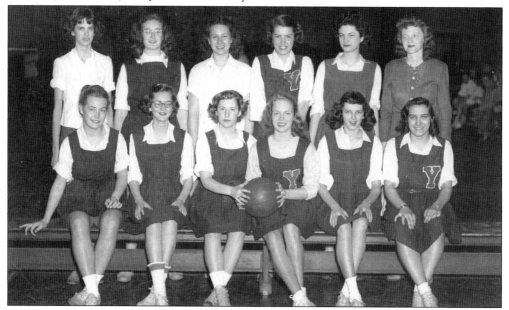

YCI fielded this girls basketball team in 1945: Carol Hopkins, Rebecca Baker, Joan Brigestocke, Sylvia Peckham, Barbara Kauffman, Diana Weeks, Joan White, Sue Daniels, Fay Motter, Jackie Wilson, and Florence Alverta Collins. The coach, top right, is listed only as "coach." Girls basketball ended in 1948 when YCI closed its doors, ceding to YJC. It did not resurface again until 1971 with the Spartanettes, coached by Jack Jacquet.

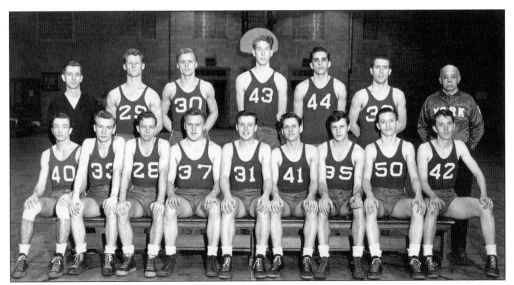

YJC's 1946–1947 men's team won the Pennsylvania Junior College League Basketball Championship. During the season the team compiled 1,430 points to their opponents' 1,003 points. The team members seen here are, from left to right, (first row) Roy Bishop, Bob Reichley, Lavere Sterner, unidentified, Jack Campbell, two unidentified, Dick Enders, and Tom Fitzgerald; (second row) coach Frank Bryant, Leonard "Red" Bock, Joe Biros, Russ Snyder, unidentified, John Chiappy, and trainer Basil Biggs. Team members not in the photograph were "Had" Collier, Zeno Lentz, Lavere Sterner, and Gearhart.

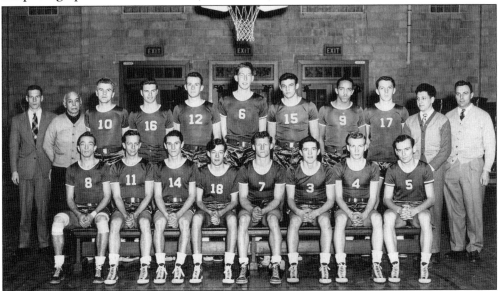

Bob Hulton, who coached the YJC basketball team for a decade, is seen here at left rear with Basil Biggs, trainer and a fixture at the college for many years. This is the 1947–1948 team, Hulton's first. The squad was beaten in the state junior college finals in an overtime game, but his teams won seven state championships in his decade as coach, six in succession. Hulton taught his students sportsmanship, fair-mindedness, and teamwork. Among his later YJC players, George Guyer in 1953 scored a record 454 points, and in 1955, Tony Arcuri hit a single game record of 47 points.

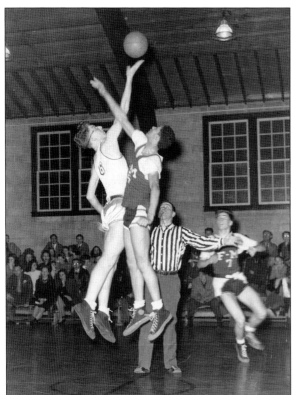

Russ Snyder, a member of the YJC Pennsylvania Junior College Championship team of 1946, jumps for the ball at tip-off in one of those games. He is wearing number 6 on his jersey. The team was called the Flying Dutchmen, a nod to the Pennsylvania Dutch heritage of York County.

An intramural volleyball game gets underway at YJC in 1943.

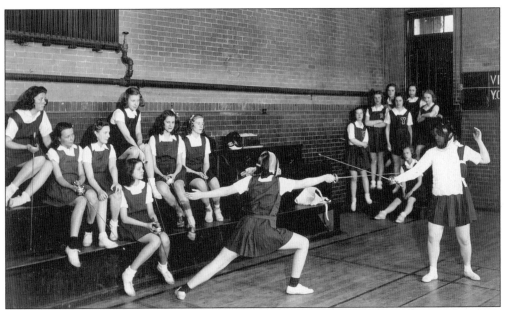

The YCI fencers pictured here in 1939–1940 are Ruth Paul and Jane Morris. From left on the bleachers are Miriam Kohr, Mary H. McClellan, Mary M. Root, Nina Ehrenfeld (top), Jean Williams (bottom), Madelyn Bowen, and Phyllis Bowen. On the steps at right are Charlotte Dempwolf, JoAnn Wisotzkey, Marian Hartzell, Julia Kurtz, Katherine Steacy, Janet Smith. Constance Whiteley is sitting on the steps. Most of these girls also played on the basketball team.

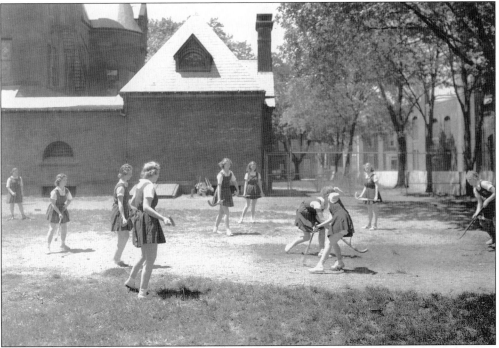

YCI girls play field hockey on the school grounds in 1945. The laboratory annex to the main building is in the background.

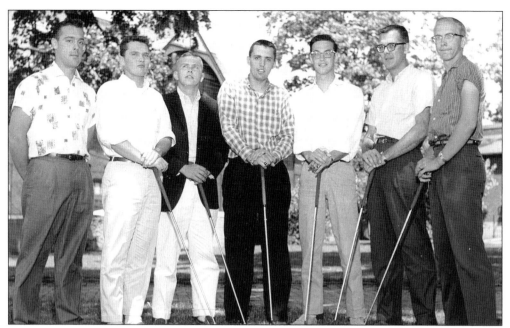

Coach Herb Sauder, left, took over as coach of the 1957–1958 YJC golf team, succeeding Bob Hulton, a multisport coach at YJC for a decade. Also pictured is Robert Green, center. Other team members are unidentified. Hulton's 1955–1956 golf team had its first undefeated season with players Nathan Madanick, John Mundis, Fred Leathery, Robert Kochenour, and Jack Downs. Hulton left YJC to become basketball coach at Gettysburg College.

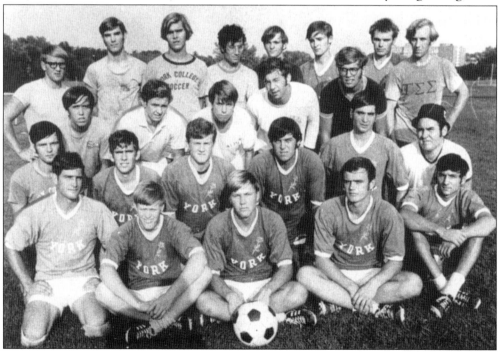

This photograph shows the 1968–1969 men's soccer team. George Shorb, left front, is the only team member identified.

*Seven*

# STUDENT LIFE

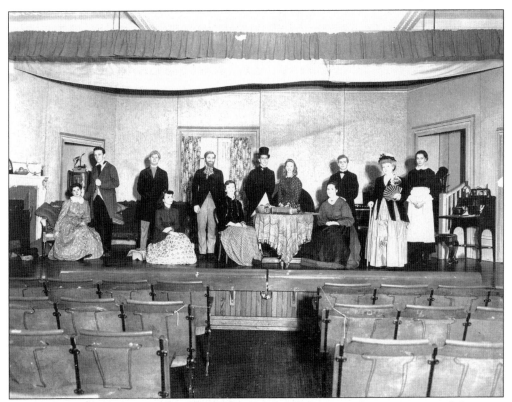

YJC students in 1943 presented *Little Women* as their major dramatization of the year. The cast included, from the left to right, Margaret Lindemuth, Wendell McMillan, Curtis Allison, Dorothy Sneeringer, William Meisenhelder, Zoe Fulton, Chester Quickel, Dorothy Ann Jenkins, Lois McWilliams, David Hoke, Mary Jane Yohe, and Bette Jane Metzler.

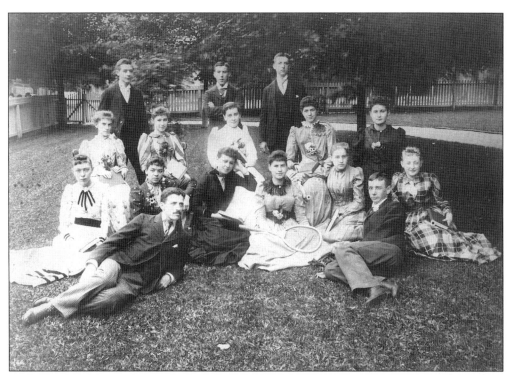

A group of students from YCI relaxes on the lawn after what appears to have been a game of tennis. The photograph was taken during the period known as the Gay Nineties.

Students from YCI lounge in front of the building in this photograph taken during the 1890s.

Friends attend a YCI class party in 1920 in Mary Gotwald's barn at the rear of 153 East Market Street in York. They are, from left to right, (first row) Jeanette Cook, Clara Hartley, Andria Taylor, Eleanor Spencer (teacher), Edna Barnes, Sara Weiser, and Helen Paxton; (second row) Mary Gotwald, Lew Elliott, Emma Shue, Bill McNamee, Katharine Ruby, John Callkin, Carl Vogel, Bobby Farquhar, Arthur Walker, Andrew Hershey, Joseph Gilbert, and Luther Gotwald (Mary's brother). Elliott, Luther Gotwald, and Cook are not YCI students.

The YCI's Phi Sigma Literary Society is shown here around 1902. Some names on the photograph cannot be deciphered. The photograph includes, Fisher Ehrhart, right, third row; Fred Dempwolf, fifth from left, third row; Prof. A. B. Carner, second from left, second row; Dr. E. T. Jeffers, fifth from left, second row; Dr. Charles H. Ehrenfeld, sixth from left, second row; and Prof. R. Z. Hartzler, extreme right, second row.

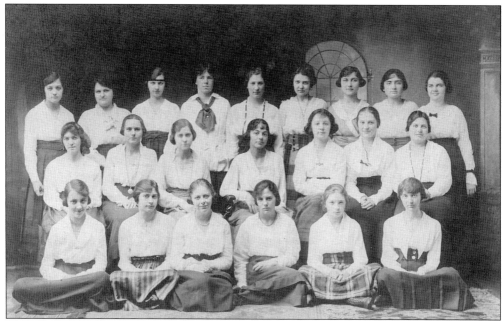

YCI members of Sigma Delta Literary Society are pictured here in 1919. They are, from left to right, (first row) Katherine Givler, Margaret Rhodes, unidentified, Tina Swartz, Isabella Baird, and Heather Hostetter; (second row) Helen Neuman, Francis Polack, Dorothy Buch, Mary McFall, Ruth McLean, Mary Rudisill, and Eva W.; (third row) Madeliene Fry, Marion Seitz, Mary Moore, L. Taylor, Margaret Klinedinst, Margaretta Lee, Eleanor Gillespie, C. Stallman, and Sarah T.

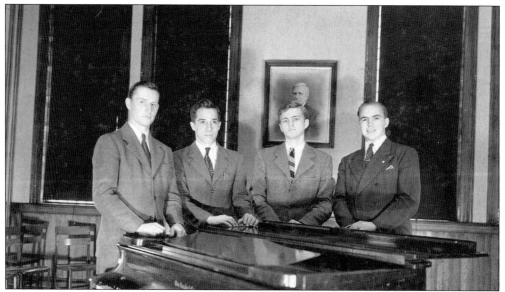

The Glee Club of YJC in 1943 included 21 members who met weekly under the direction of E. E. Schroeder. Within this group was a quartet of talented vocalists that won recognition for the college singing over the radio and at assembly programs and church services. The quartet, pictured here, includes Jack Busler, first tenor; John Spangler, second tenor; William Meisenhelder, baritone; and Richard Goodling, bass.

Is the entire class astonished by something? No, it is just a view of the YJC chorus practice in the 1960s as they follow the chorus director Ralph Woolley.

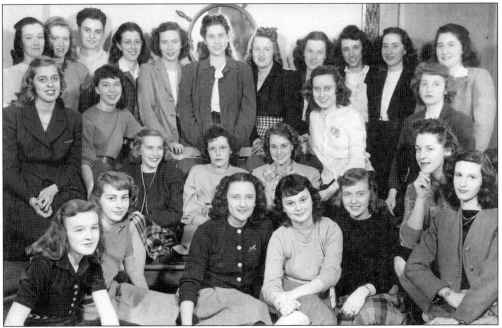

Lambda Sigma Chi sorority girls at YJC group for this photograph in 1947. Partial identifications include: Norma Schmuck, middle of front row; Gloria Schlaline, top row, second from left; Phyllis Ahrens, middle row, left end; and Mary Hyde Butler, class of 1947, second row, down on right with "MHB" on a white sweater. The sorority was started by the class of 1942.

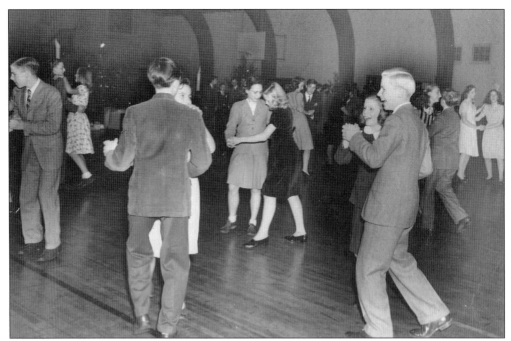

YJC students enjoy the Christmas dance in 1948. The dances were usually held at the Out Door Country Club.

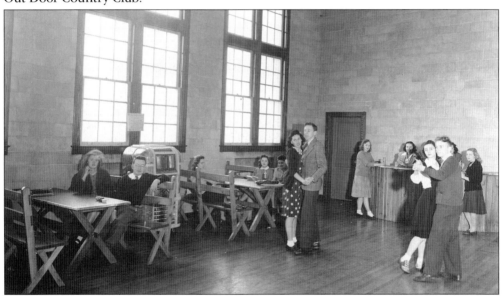

YJC students, pictured here in 1945, also liked to dance at the snack bar, which was outfitted with a jukebox. This grew from a student council idea to a full-blown YJC project. The snack bar, with Frank M. Bryant and Mary Louise Van Horn as advisors, became a rendezvous for students. Furniture arrived unpainted and students got out the shellac. A milk machine appeared, followed by a cookie and candy machine. To meet expenses, food was donated and sold by the students. A jukebox was installed enabling students to "glide to the jive." They passed the time eating pie and ice cream and dancing to "Rum and Coca-Cola" or just talking.

The morning of February 4, 1946, YJC was invaded by an army of 85 ex-GIs, requiring 18 new courses and new faculty to teach the courses. That year student council members included William Goodling, future U.S. congressman. The YJC student council members pictured here in the 1947 yearbook, named the *Tower*, from left to right are Donald "Irish" McCloskey, secretary Ethel Minster, treasurer James Bortner, president Joseph F. Jennings, vice president Jean M. Rost, Ann Ziegler, and Miss Wilt.

The first *Tower* yearbook debuted in 1943. The 1947 *Tower* staff at YJC included Michael Deckman, editor-in-chief, and Ethel Minster, managing editor. The year 1947 brought changes to YJC. The institution began offering a first-year engineering curriculum and established a program with York Hospital School of Nursing that brought preclinical nursing courses to YJC.

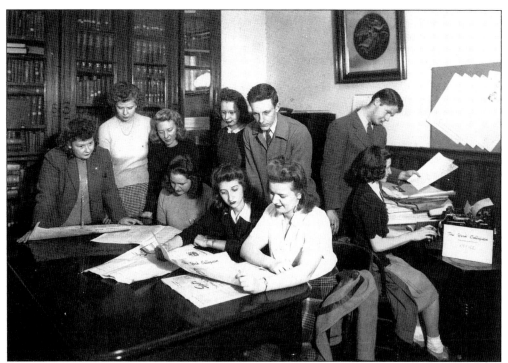

The 1943 staff of the YJC newspaper, the *York Collegian*, pores over a copy of the paper. Seen here are, from left to right, (seated) Lois McWilliams, Lois Gilbert, Betty Jane Swartz, and Dorothy Crone; (standing) Mary Jane Yohe, Dorothy Leeper, Dorothy Ann Jenkins, Audria Stinger, Wendell McMillan, and Curtis Allison.

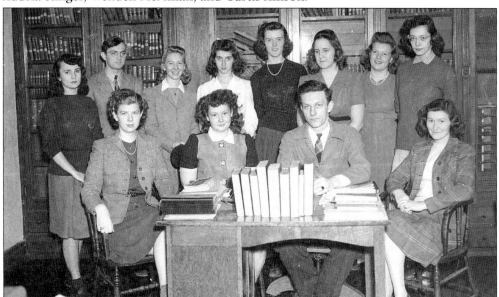

The staff of the *Tower*, the YJC yearbook, gets ready to do some work in this 1943 photograph. From left to right are (first row) Dorothy Leeper, Mary Jane Yohe, Wendell McMillan, and Dorothy Crone; (second row) Dorothy Sneeringer, David Hoke, Dorothy Ann Jenkins, Lois Gilbert, Zoe Fulton, Lois McWilliams, Betty Jane Swartz, and Bette Jane Metzler.

Members of YJC's Lambda Sigma Chi sorority attend a tea given by president J. F. Marvin Buechel's wife during the 1956–1957 school year. Seen here are, from left to right, Lorraine Tracy, Jane Mosebrook, Patricia Cavanaugh, Mary Rohrbaugh, Lorna Gross, Marcia Crouch, Julia Barnes, Sara Jane Uffelman, and Ruth Miller, seated on the floor.

Playing cards in the Dutchman's Pub was a popular pastime during free periods at YJC in 1966.

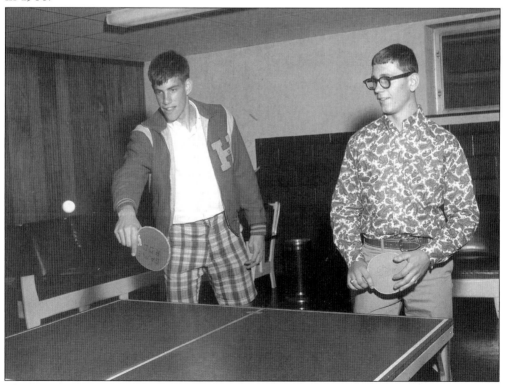

Chip Arnold and Chester Thomas try a little Ping-Pong in the game room of YJC Student Center in 1966.

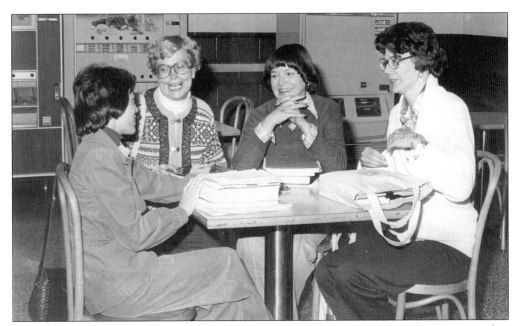

Students Marsha Carupella, Flossie Ludvigrsen, Louise Alosa, and Rosemary Martin chat at a table in the Dutchman's Pub in 1977.

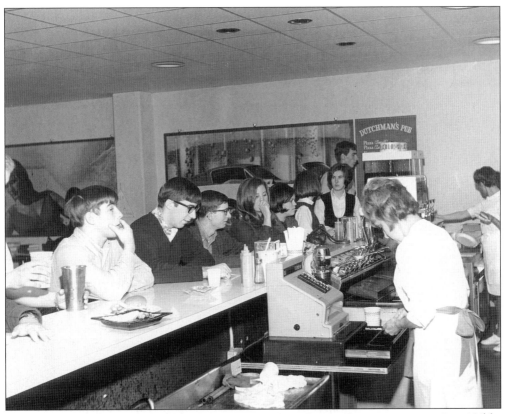

Students pause for a snack at the Dutchman's Pub in the Student Center at YJC in 1966.

Students check into a dormitory in 1962. Jean Hammond is the assistant resident counselor behind the desk.

Marguerite Edmondson, a resident counselor at Springettsbury Hall, and her assistant Jean Hammond look over some paperwork in 1962.

100

Once upon a time, when in loco parentis reigned supreme, girls' dormitories had housemothers who carefully watched over their flock and enforced curfews. This is housemother Lillian Sowers.

This group is just hanging out, but check the fashionable knee-highs these girls from the 1960s are sporting.

It is move-in day in the fall of 1983. One student leads the way while dad follows with a heavier load. Their destination is an assigned room in a dormitory somewhere on campus.

Three new students enjoy their surroundings inside Tyler Run Apartments in 1989. They seem happy with their accommodations in one of the new residence halls.

Two unidentified students chat in their YCP dorm room in Tyler Run Apartments in the 1980s.

Four guys are doing some serious looking. Checking out girls, perhaps?

The Dusty Road Singers compete at the 1966 YJC Talent Show. They are Dave Ginter, Jeff Smith, and Pete Minier. No word on how they made out on the applause meter.

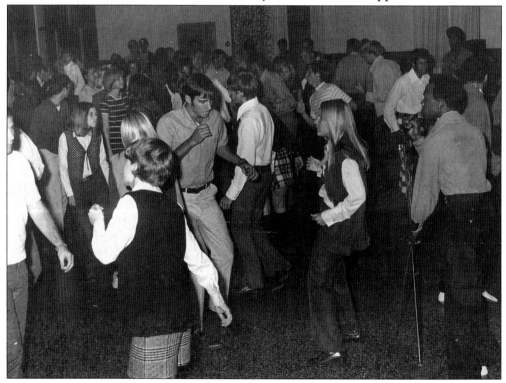

My how dance styles have changed! In this photograph, a more current group of YCP students crowds the dance floor and demonstrates their moves.

Run out of quarters for the washing machine? This group of guys at Tyler Run appear to be doing laundry. Or perhaps it is a science project and they are checking the quality of the water.

Now how did those golf balls get into that tree? Their golf swings could not possibly be that bad.

Spring Festival time means it is also time to indulge in the manly art of grilling. Some YCP presidents have been known to invite students to grill on the president's lawn.

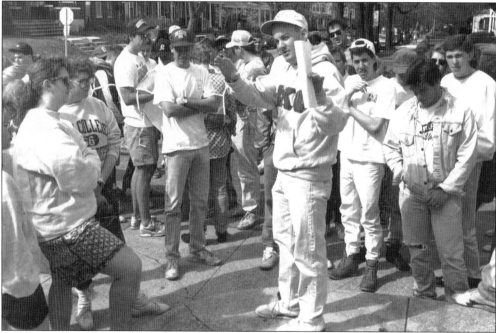

Bradley Jewitt summons some 1970s student volunteers to clean and sweep the blocks around the college campus. The neighborhood cleanup is a regular activity undertaken by student organizations to foster a good "town and gown" relationship between homeowners and the students who rent off-campus apartments in the area.

Joane Stambaugh and Lonnie Darr enjoy a spring day in 1975 and contemplate the "Rock" painted by the class of 1974. Painting the Rock green is a tradition with each graduating class. Members of each graduating class then put their names and messages on the Rock at commencement. The names remain there until the next graduating class paints it. The Rock is a large chunk of York County limestone, dubbed "Old Spart" and first painted deep green by the class of 1972. A new rock replaced the original in 1996 after it was dropped and smashed into pieces when construction workers tried to move it to a new location.

These newly graduated students are busy painting their names on the Rock.

Sometimes it is nice to forego the library and the dormitory room for the tranquility of the shade under a fine, old tree on campus. If this student is not careful, he might nod off and miss his next class.

A student in the early 1960s climbs the hill from a parking lot toward buildings just beginning to spring up on the new campus of YJC. At the top of the photograph, on another hill on the other side of the Susquehanna Trail, is York Hospital, which dates back to 1880. New construction on the campus now blocks this view.

# *Eight*

# Making a Difference

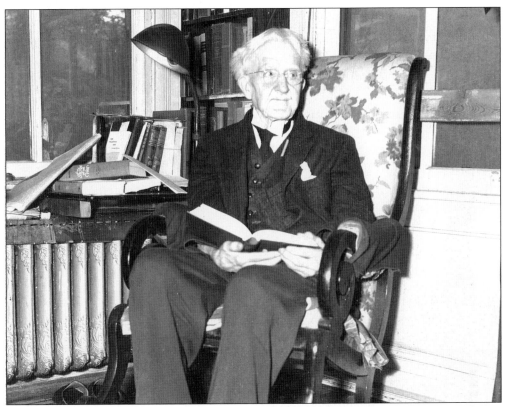

Francis Farquhar was a lawyer, industrialist, civic leader, alumnus of YCI, and benefactor of YJC. He was the son of self-made millionaire A. B. Farquhar, who founded a company bearing his name that made farm equipment, steam machines, and other industrial equipment. The company was sold in 1952 to the Oliver Corporation. Two years prior to Francis Farquhar's death on November 7, 1965, at age 97, he gave his valuable collection of 4,161 volumes to the YJC library. He was in the class of 1885 at YCI before going to Yale Law School. A brother Percival attended YCI 1874–1875 and later became known as the "Master Builder of South America."

The 1966 board of trustees of YCP meets in the west wing of the library. Present in this image are Charles Seligman, Melvin H. Campbell, Walter S. Ehrenfeld, Herman Gailey, John Waltersdorf, George Small, Dr. Bruce Grove, Benjamin Root, Marvin Sedam, Beauchamp Smith, John Schmidt, John Hennessey, Harlowe Hardinge, John Connelly, Mrs. George Schenck, and John T. Robertson.

A board of trustees from another year has yet another meeting. They are, from left to right, (first row) Elliott Breese, Russel G. Gohn, John C. Schmidt, and Joseph R. Wilson; (second row) W. Burg Anstine, Esq., Dr. Bruce A. Grove, and Mrs. Jesse Chock; (third row) Mrs. George Schenck, Raymond S. Noonan, Dr. Herman A. Gailey, Harlowe Hardinge, Benjamin M. Root, John P. Connelly, Marvin G. Sedam, and John A. Waltersdorf.

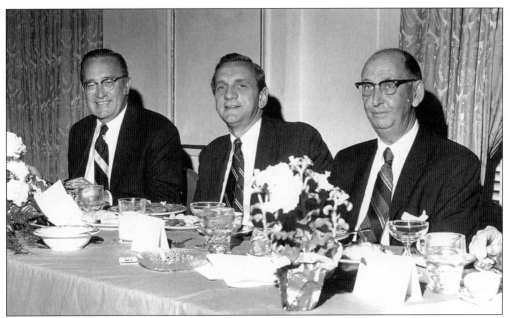

The vision, leadership, and support of these three trustees helped make YCP the institution it is today. The businessmen and industrialist devoted time, energy, and resources to the physical and academic growth of the college over a span of several decades. They are, from left to right, Charles Wolf, Louis Appell Jr., and Melvin Campbell. Campbell served 10 years as president of the board of trustees during the institution's transition from a building downtown to a new campus.

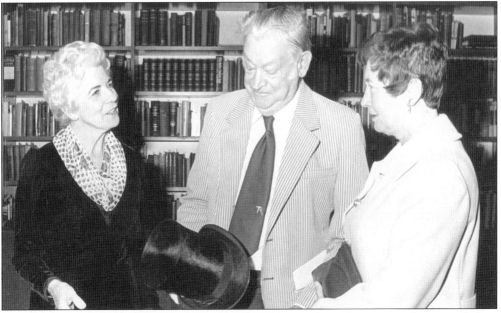

Dr. and Mrs. William Langston, who donated the Lincoln Collection to the YCP Library, are shown with college archivist and social assistant Susan Beecher, left, in the Lincoln Gallery. The occasion was Founder's Day and rededication of Schmidt Library on October 3, 1981.

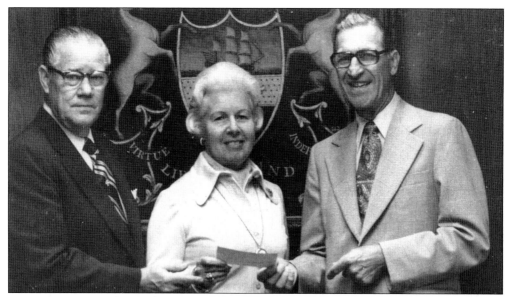

Mr. and Mrs. Russel G. Gohn, shown with YCP president Ray A. Miller, right, established the $100,000 Gohn Trust Fund at the college. Gohn was chairman of the 1966 campaign to raise $1,060,000 for a development fund needed as part of the goal to become a four-year institution. The campaign was launched in September, and by November, they had $910,000 to construct the first section of a new administration building. The campaign exceeded its goal, garnering $1,110,646 and assuring the establishment of a four-year college. On the wall behind the trio is a famous 1796 painting of the Pennsylvania Coat of Arms that was incorporated into the state seal. The work by local artist John Fisher at one time hung in Independence Hall and in the York County Courthouse. It was purchased for YCI in 1921 for $80.

Richard McCarty, YCP president Robert V. Iosue, and Vickie Anderson examine a chart showing how annual giving to the college more than tripled between 1975 and 1977.

112

The Women's Auxiliary of YCP marked its 25th anniversary in May 1980. The auxiliary over the years proved to be a vital force in supporting college endeavors. Pictured from left to right are (first row) Mrs. Melvin Campbell, Mrs. J. Kenneth Stallman, Mrs. Robert H. Stewart, Mrs. Herbert R. Euler, and Mrs. Howard D. Campbell; (second row) Mrs. Robert V. Iosue, Mrs. John Waltersdorf, Mrs. Russel G. Gohn, Mrs. J. Ronald Atwater, Mrs. Basil A. Shorb, Mrs. Charles S. Wolf, Mrs. Gerald L. Seitz, Mrs. John W. Kennedy, Mrs. John P. Connelly, Mrs. John F. Grove Jr., Mrs. F. C. Wagman, Mrs. Thomas Campbell, Mrs. Benjamin M. Root, Mrs. Frederick B. Shearer, Mrs. Bruce A. Grove, Mrs. Frederick Holmes, Mrs. D. Haydon Stouch, Mrs. John Atlains, Mrs. W. Burg Anstine, Mrs. Rodger Furee, Mrs. Franklin Eyster, Mrs. Gina Thornton Parlser, Mrs. Stephan Stock, Mrs. William S. Fry, and Mrs. John C. Schmidt.

In 1970, Allis Chalmers donated to YCP the 1939 Charles Sheeler painting entitled *Suspended Power*, which depicts an S. Morgan Smith turbine runner in the process of being installed at Guntersville Dam on the Tennessee Valley Authority system. It recognized years of service to York by Beachamp E. Smith, a college trustee, and was to go into the college's fine arts collection. At the time of its donation, it was valued at $35,000. Over the years, the college received offers of up to $240,000 for the painting and eventually locked it in a vault, fearing for its safety. It finally was sold in 1982 for $350,000 to create the Beachamp E. Smith Memorial Scholarship Fund. By 1985, it was valued at over $1 million, and after that described as "priceless." It is now in the Dallas Museum of Art.

Students Gerald Donges and Bobbi Ann Bell were recipients of the first annual Gladfelter Trust Award established by Dr. Millard E. Gladfelter, a YCA graduate and past president of Temple University. The award goes to rising senior students who demonstrate high levels of scholarship in social studies and especially American history. Also pictured are Dr. Philip Avillo, left, then chair of YCP's history and political science department, and YCP president George Waldner.

# *Nine*

# DISTINGUISHED GUESTS

Pres. Gerald R. Ford (right) was speaker at the Henry D. Schmidt Memorial Lecture September 26, 1979. YCP president Robert V. Iosue and his wife Christina are shown with Ford as they leave the Iosue's residence for the lecture hall.

Philip H. Glatfelter III was the speaker at the 1971 YCP commencement exercises, significant for being the first class to graduate from the four-year-college program. Glatfelter, chairman and president of the P. H. Glatfelter Company, is a descendant of Charles Glatfelter, who once owned the land on which today's YCP was built. Philip Glatfelter, in 1977, received an honorary degree from the college.

Margaret Moul, with president Ray A. Miller, looks at the doctorate of humane letters that she received from YCP in 1973. Moul for 25 years was executive director of the Easter Seal Society of York. A dedicated and caring teacher, she operated the first preschool for children with cerebral palsy. It evolved into the York County Society for Cerebral Palsy (later the Easter Seal Society for Children and Adults.) She founded the Margaret E. Moul Home, which opened January 5, 1982, as an alternative to the typical nursing home facilities unable to accommodate a growing number of disabled individuals needing skilled care.

Gen. Jacob Loucks Devers received an honorary doctor of humane letters from YCP in May 1974. A local and national hero, Devers was born in York in 1887, attended West Point Military Academy and was commissioned in June 1909. He was largely responsible for the planning of the Normandy-area landing. A four-star general, he was commander general of the European theater of operation and deputy supreme allied commander in the Mediterranean theater in World War II. A York elementary school bears his name.

Pennsylvania's 19th district congressman George A. Goodling, second from right, received an honorary doctor of laws degree from YCP in May 1975. Pictured from left to right are YCP president Ray A. Miller; Bill Goodling, who would succeed his father as the district's congressman; George A. Goodling; and Charles Wolf, chairman of the YCP board of trustees. George A. Goodling attended YCI and his son attended YJC.

Weightlifter Bob Hoffman, who made York the barbell capital of the country, is pictured with student Jennifer Brown at an awards recognition dinner at YCP in 1975.

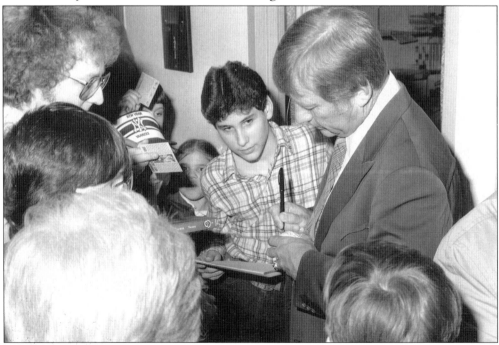

Slugger Mickey Mantle signs a ball for a young fan during a visit to YCP. The year is unknown.

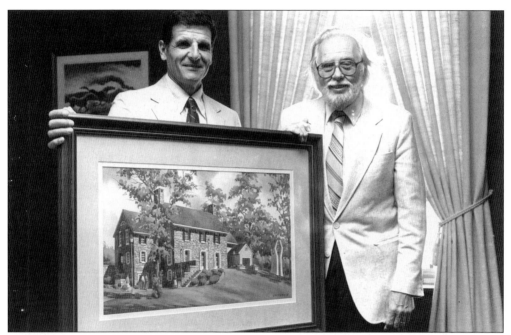

YCP president Robert V. Iosue, left, is shown here with York artist William Falkler and Falkler's painting of the campus chapel.

Walt Partymiller, local artist and political cartoonist for the York *Gazette and Daily*, is shown with his rendering of the pedestrian footbridge over Tyler Run on the YCP campus. An exhibit of Partymiller's political cartoons was on display at the YCP library during March 1978.

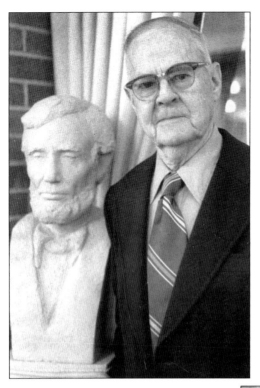

Dr. Richard Mudd, grandson of the physician who set the broken leg of John Wilkes Booth, lectured on "the Lincoln Conspiracy and the Case for Dr. Mudd" on November 21, 1984. The photograph was taken outside the Lincoln Room of Schmidt Library.

Lynne Cheney, chairman of the National Endowment for Humanities, received an honorary doctorate from YCP in January 1991. Cheney was guest speaker on February 6, 1991, at "A Celebration of Learning." Her husband, Dick Cheney, would later become vice president of the United States in the George W. Bush administration.

*Roots* author Alex Haley lectured and autographed copies of his book at YCP in February 1984.

U.S. Secretary of Education William J. Bennett was guest speaker in 1987 at a convocation marking the 200th birthday of YCA, the ancestral institution that was the foundation upon which YCP grew.

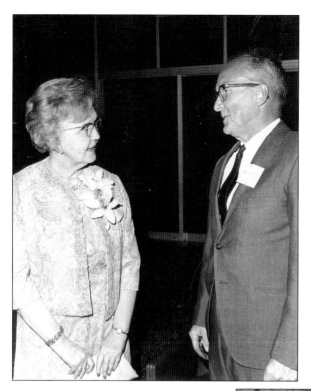

Helen McNitt, English professor and yearbook advisor, greets M. C. Fultz of Lancaster, a high school classmate she had not seen since 1921. The 1961 occasion marked McNitt's 20-year anniversary at YJC.

Helen Miller Gotwalt, honorary degree recipient from YCP in 1988, taught 40 years in York City public schools with 23 years as head of Hannah Penn Junior High School's English department. Seeing educational value in television, she coordinated radio and television usage for city schools 1955–1963. She wrote 300 children's plays and a history of York County Courthouse, *The Crucible of the Nation,* earning distinguished Pennsylvanian honors for dual achievements as teacher and writer.

Former two-term Pennsylvania governor Richard L. Thornburg (1978–1986) received an honorary degree from YCP at the 1988 commencement. At the time, he was director of the Institute of Politics at Harvard University's John F. Kennedy School of Government and partner in the Pittsburgh law firm of Kirkpatrick and Lockhart. He went on to serve as U.S. attorney general (1989–1991) in the George H. W. Bush administration.

Guest lecturer William Buckley, left, shown with YCP president Robert V. Iosue, shakes hands with staunch YCP supporters Frances and Phyllis Wolf. Buckley, a syndicated columnist and conservative commentator, founded the *National Review* magazine.

On March 23, 1987, Dr. Bruce Grove, YCP president Ray A. Miller, Frank Bryant, and Bob Reichley (shown here from left to right) marked the 40th anniversary of coach Bryant's 66-44 win over Hazelton to take the 1947 Pennsylvania State Junior College Basketball Championship. Grove and Reichley were on the team, which Leonard "Red" Bock, a guard, and Russ Snyder led to victory. It was the best basketball season for the Flying Dutchmen in the short history of YJC, with 21 wins in 25 starts plus becoming the first champions of the newly organized state league.

Dr. Philip A. Hoover, recipient of an honorary degree from YCP at the December 1990 commencement exercises, was a prominent York physician for 52 years until his retirement in 1989. Hoover Library in the Medical Education Pavilion of York Hospital provides testimony to his achievements. He also was a historian and civic leader. His son, Dr. Benjamin Hoover II, was a YCP trustee, 1993–2001. Architect and engineer Donald A. Gilbert, who designed most of YCP's main campus, also received an honorary degree at the 1990 commencement.

## *Ten*

# BUILDING FOR THE FUTURE

When students returned to the main campus for the start of the 2006–2007 academic year, they found construction equipment attacking the old Wolf Gymnasium, clearing out partitions, wrecking the old swimming pool, and preparing concrete supports for a new theater/auditorium/classroom complex that would be the new home for the Department of English and Humanities and Department of History and Political Science. The demolition, followed by new construction, was the culmination of planning and millions of dollars that went into the 2002–2007 strategic plan, but it was not the end of demolition and construction on the campus. New projects are in the future under the 2007–2012 strategic plan. They include renovation of the Business Administration building and moving biological sciences into space in the Appell Life Sciences Building vacated by relocation of the humanities and social sciences faculty.

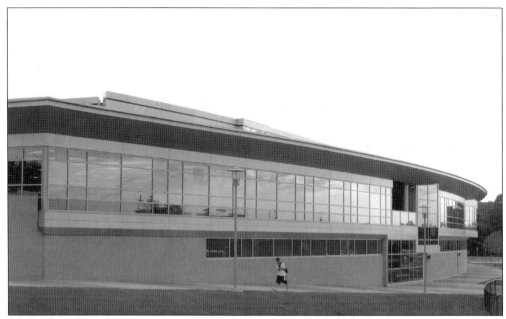

Grumbacher Sport and Fitness Center, opened April 29, 2006, and named for Tim and Nancy Grumbacher, is the showpiece of the West Campus. It houses the "new" Charles Wolf Gymnasium, three-court field house, fitness center, elevated jogging track, natatorium, two-story climbing wall, and classrooms. The Wolf family transferred its name to the new gymnasium. The old gymnasium honored Charles Beck Wolf (1891–1951). The new name uses no middle initial, so it also honors his son and former trustee, Charles Samuel Wolf (1921–1998).

An artist's rendering shows the Humanities Center, dedicated October 6, 2007, as the new home of the Departments of English and Humanities and History and Political Science. It occupies the site of the demolished old Wolf Gymnasium on the main campus. An adjoining 750-seat theater/auditorium with a two-story atrium, to be finished in 2008, will make this the tallest building on campus.

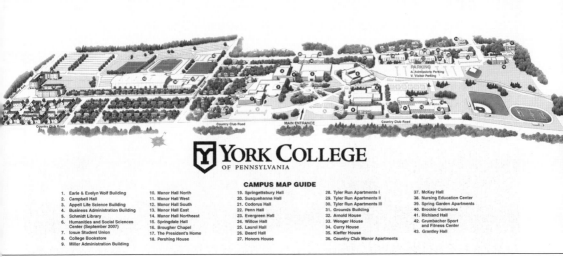

# Y YORK COLLEGE
OF PENNSYLVANIA

## CAMPUS MAP GUIDE

| | | | | |
|---|---|---|---|---|
| 1. Earle & Evelyn Wolf Building | 10. Manor Hall North | 19. Springettsbury Hall | 28. Tyler Run Apartments I | 37. McKay Hall |
| 2. Campbell Hall | 11. Manor Hall West | 20. Susquehanna Hall | 29. Tyler Run Apartments II | 38. Nursing Education Center |
| 3. Appell Life Science Building | 12. Manor Hall South | 21. Codorus Hall | 30. Tyler Run Apartments III | 39. Spring Garden Apartments |
| 4. Business Administration Building | 13. Manor Hall East | 22. Penn Hall | 31. Grounds Building | 40. Brockie Commons |
| 5. Schmidt Library | 14. Manor Hall Northeast | 23. Evergreen Hall | 32. Arnold House | 41. Richland Hall |
| 6. Humanities and Social Sciences Center (September 2007) | 15. Springdale Hall | 24. Willow Hall | 33. Wenger House | 42. Grumbacher Sport and Fitness Center |
| 7. Iosue Student Union | 16. Brougher Chapel | 25. Laurel Hall | 34. Curry House | 43. Grantley Hall |
| 8. College Bookstore | 17. The President's Home | 26. Beard Hall | 35. Kieffer House | |
| 9. Miller Administration Building | 18. Pershing House | 27. Honors House | 36. Country Club Manor Apartments | |

This campus guide, which shows buildings on both the Main and West Campuses, illustrates how YCP has spread geographically since moving nearly 50 years ago from an 1886 building in downtown York to a 57.5 acre former golf course. The original campus along Country Club Road did not include abutting former industrial sites that were acquired and developed as the West Campus, increasing the total campus size to 155 acres. Not shown on this map is the new Engineering Innovation Center that will put computer science, electrical and computer engineering, and mechanical engineering programs under one roof at Grantley and Kings Mill Roads. The college is in the process of converting the former York Narrow Fabrics Company into the engineering center. The 80-year-old plant had been vacant for a year. In its heyday, it was the official home of government red tape—manufacturing the woven quarter-inch red tape that the federal government used to tie up its printed documents. The next five-year strategic plan will continue to involve demolition, gutting, renovating, and rebuilding to meet the ever-changing needs of nearly 5,000 full-time students.

ACROSS AMERICA, PEOPLE ARE DISCOVERING
SOMETHING WONDERFUL. *THEIR HERITAGE.*

Arcadia Publishing is the leading local history publisher in the United States. With more than 3,000 titles in print and hundreds of new titles released every year, Arcadia has extensive specialized experience chronicling the history of communities and celebrating America's hidden stories, bringing to life the people, places, and events from the past. To discover the history of other communities across the nation, please visit:

# www.arcadiapublishing.com

Customized search tools allow you to find regional history books about the town where you grew up, the cities where your friends and family live, the town where your parents met, or even that retirement spot you've been dreaming about.